New York is...

New York is...

THE METROPOLITAN
MUSEUM OF ART

Abrams
New York

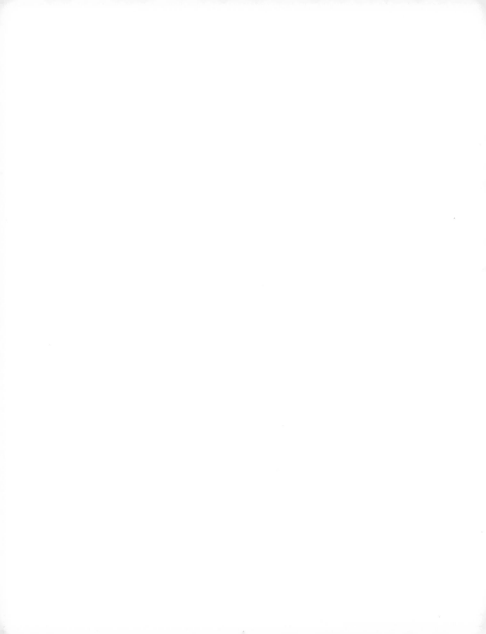

NEW YORK CITY is a place of possibility. From people to experiences, from cultures to religions, from politics to economics, the possibilities are endless. These endless possibilities make New York the most diverse city in the world, a city that cannot be described in a single word.

In fact, this book uses nearly two hundred words to describe the global metropolis on the Hudson River. Illustrated with works of art from The Metropolitan Museum of Art's collection, the words in the following pages are concise reflections on Gotham. New York is shape, New York is line. New York is finance, New York is industry. New York is bustling, New York is deserted. Some of the words speak to observations and experiences, while others reference the accompanying work of art.

All of the selected works of art reach across the Museum's collection from paintings and costumes to sculpture and contemporary photographs. Detailed commentary about the works can be found on the Museum's website at www.metmuseum.org.

Because anything is possible in Gotham, readers are encouraged to observe and to create their own descriptions of New York.

New York is shape,

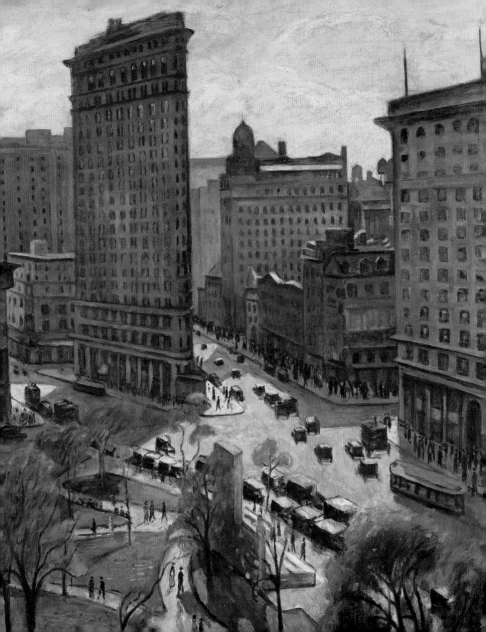

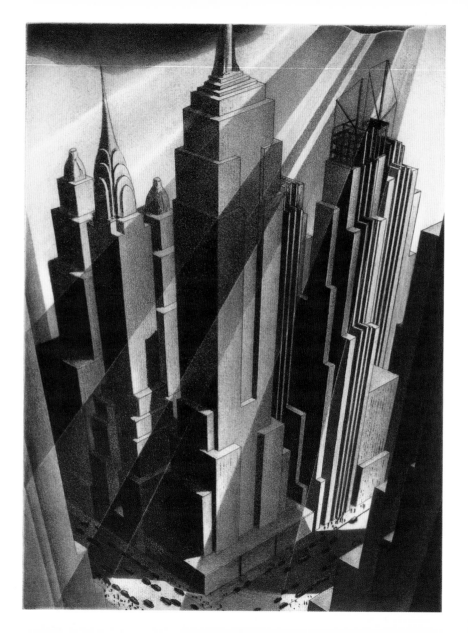

New York is line.

Man's Canyons

Samuel L. Margolies, American, 1897–1974

Etching and aquatint, 11 7/8 × 8 13/16 in., 1915–54

Gift of Associated American Artists, 1954 54.647.80

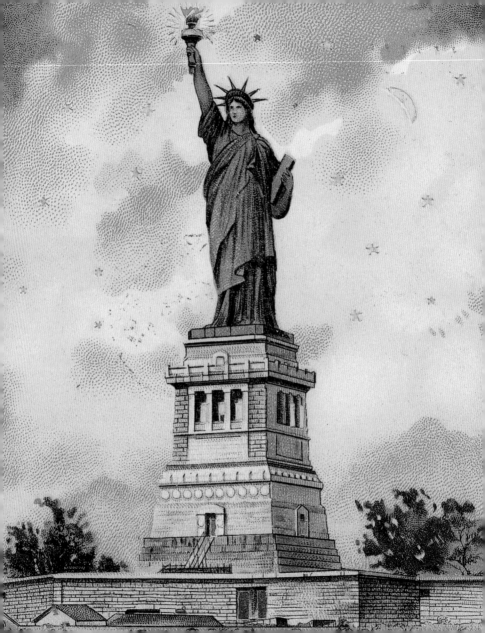

New York is iconic,

New York is unfamiliar.

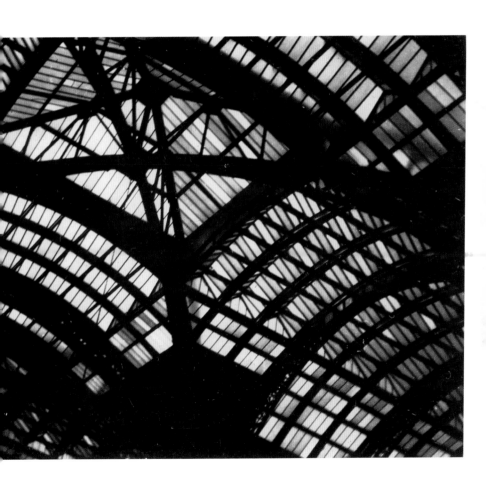

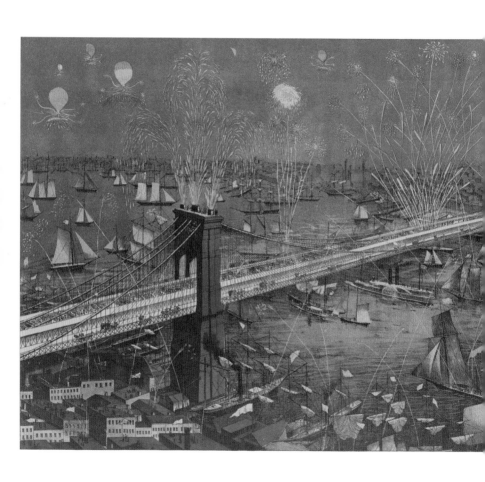

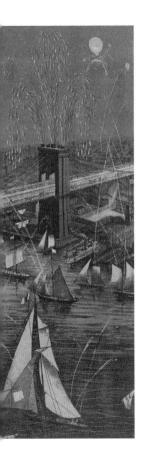

New York is dynamic,

*Bird's-Eye View of the Great New York and Brooklyn Bridge, and
Grand Display of Fireworks on Opening Night . . . May 24, 1883* (detail)
Published by A. Major, American, 1883
Color lithograph, 18⁷/₈ × 26¹/₄ in.
The Edward W. C. Arnold Collection of New York Prints,
Maps, and Pictures, Bequest of Edward W. C. Arnold, 1954 54.90.709

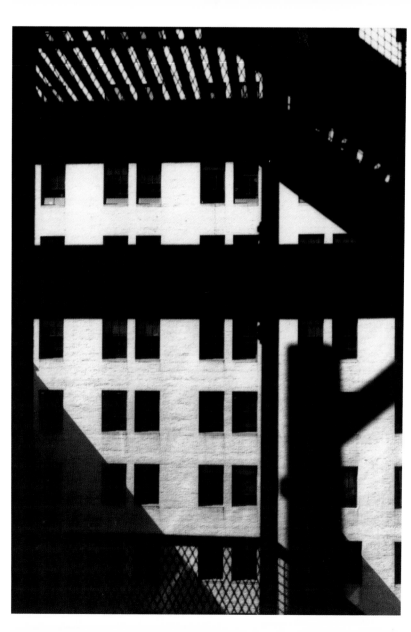

New York is static.

New York is illustration,

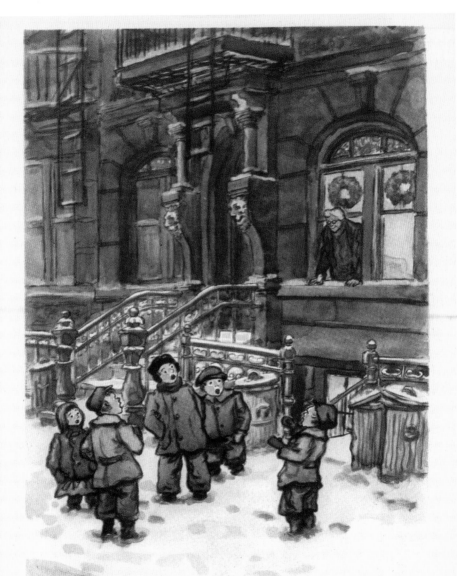

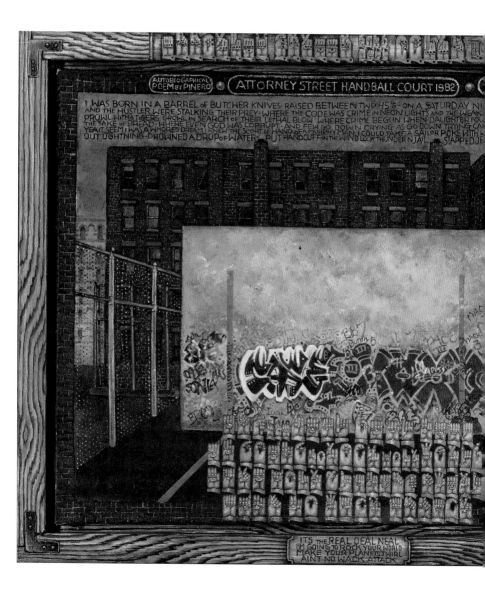

AUTOBIOGRAPHICAL POEM BY PINERO · ATTORNEY STREET HANDBALL COURT 1982 ·

I WAS BORN IN A BARREL of BUTCHER KNIVES · RAISED BETWEEN TWO 45's · ON A SATURDAY NI
AND THE HUSTLER WERE STALKING THEIR PREY · WHERE THE CODE WAS CRIME IN NEON LIGHTS and THE WEAK
PROWL WITH TIGERS · GROWL IN SEARCH of THEIR LETHAL BLOW · WHERE CRIME BEGUN WHEN DAUGHTER FOU
THE SAKE of BREAD · WHERE EVEN GOD WAS CORRUPT · AND FEW GO DOWN CRYING AS GO DOWN TRYING CA
YEAR SEEM I WAS A WHORES DREAM I KNEW THE SLIGHT of HAND of A MURPHY MAN I COULD TAKE A SAILOR POKE WITH
OUT LIGHTNING · DROWNED A DROP of WATER · PUT HANDCUFF on THE WIND LOCK THUNDER IN JAIL · SLAPPED JE

ITS the REAL DEAL NEAL
I'M GOING TO ROCK YOUR WORLD
MAKE YOUR PLANETS TWIRL
AIN'T NO WACK ATTACK

New York is graffiti.

Attorney Street (Handball Court with Autobiographical Poem by Piñero)

Martin Wong, American, 1946–1999

Oil on canvas, 35¹/₂ × 48 in., 1982–84

Edith C. Blum Fund, 1984 1984.110

New York is industry,

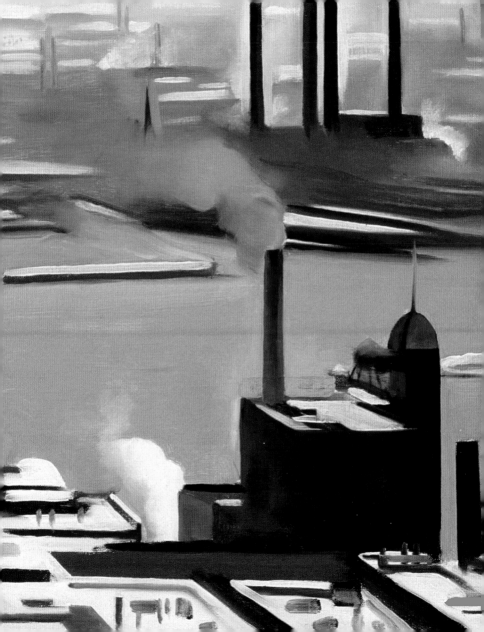

New York is finance.

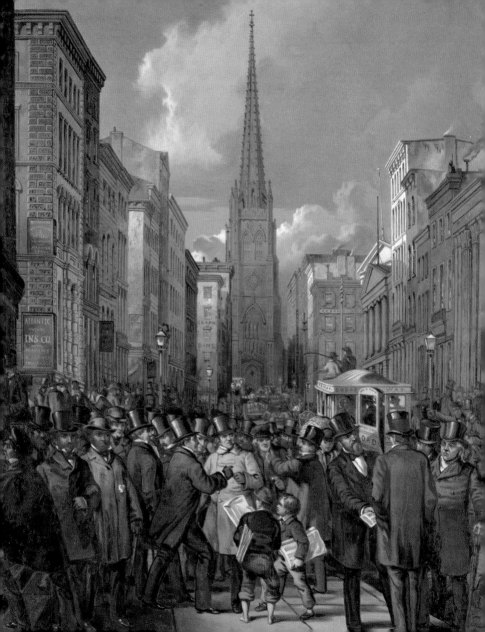

New York is a
walk in the park,

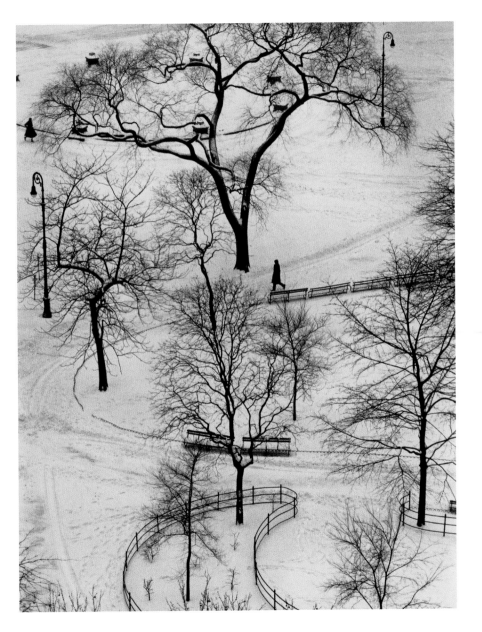

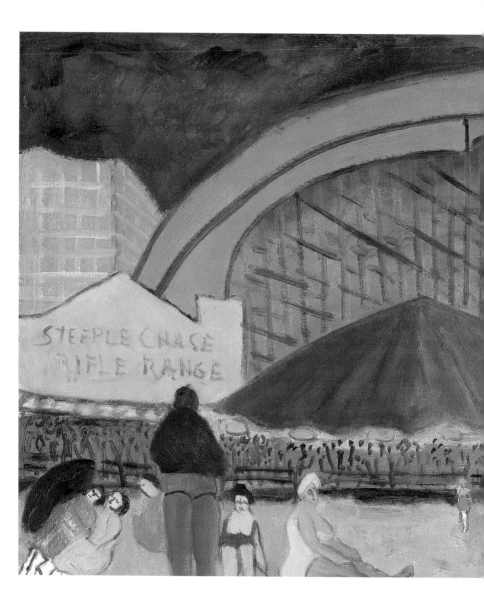

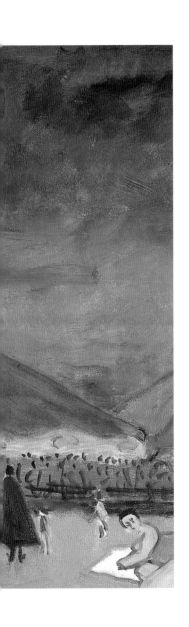

New York is a day at the beach.

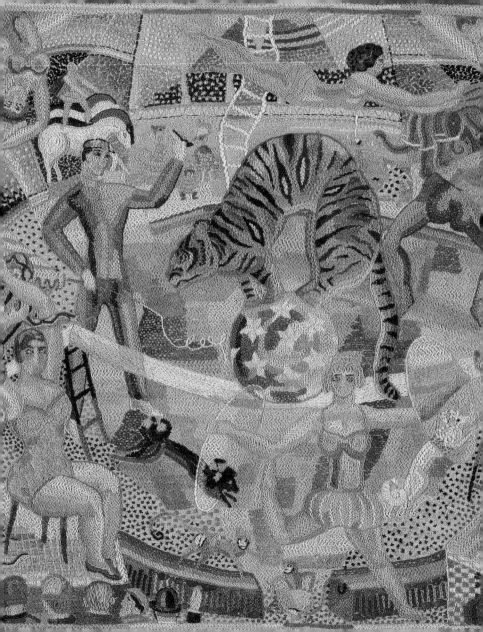

New York is spectacle,

New York is commonplace.

New York is light,

New York is shadow.

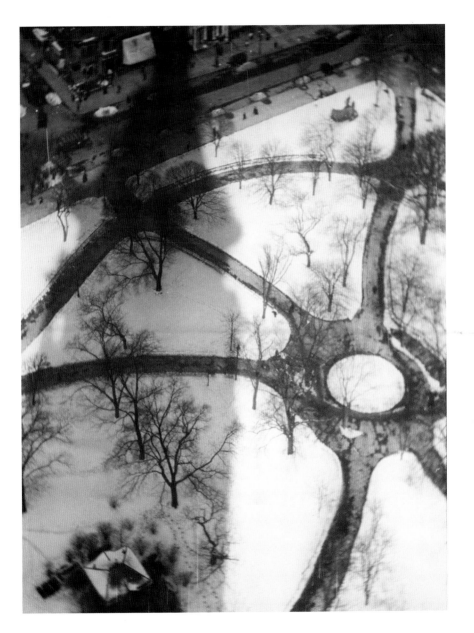

New York is shared spaces,

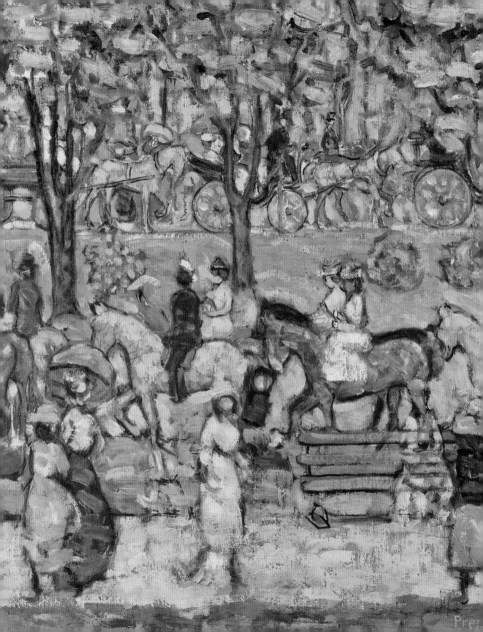

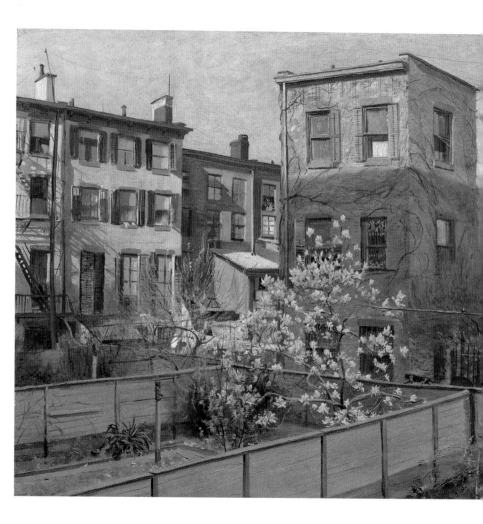

New York is
secret gardens.

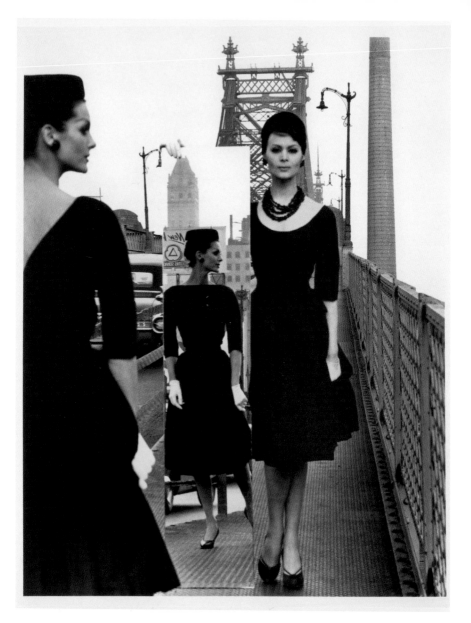

New York is glamour,

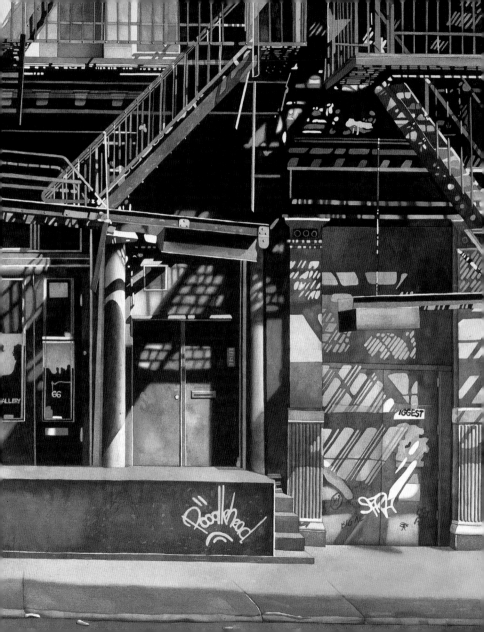

New York is grit.

New York is organized,

The City of New York: Longworth's Explanatory Map and Plan (detail)

James DeForest Stout, American, 1783–1868

Printed by Daniel Fanshawe, American, 19th century

Hand-colored engraving, 19⅛ × 19⅛ in., 1817

The Edward W. C. Arnold Collection of New York Prints, Maps, and Pictures,

Bequest of Edward W. C. Arnold, 1954 54.90.630

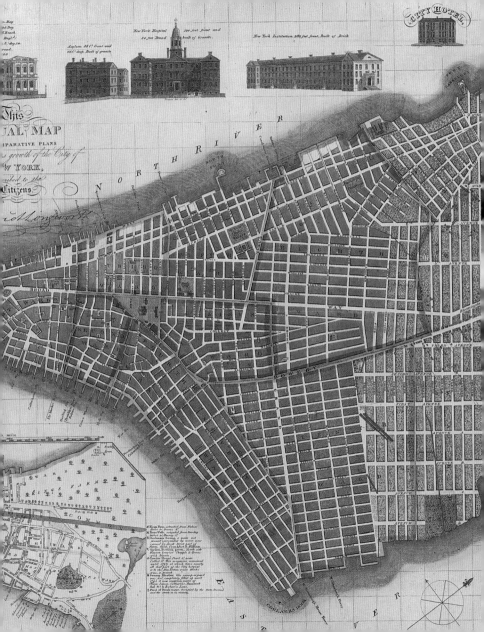

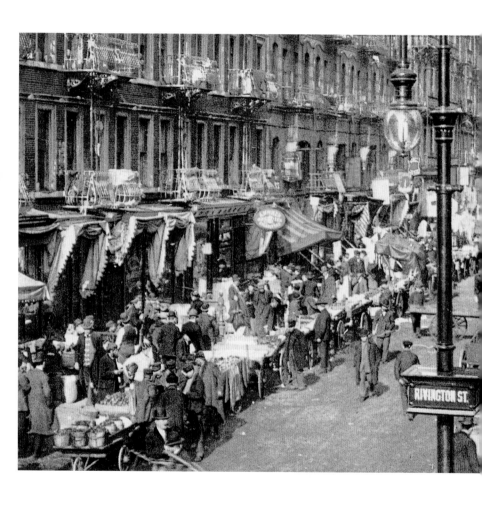

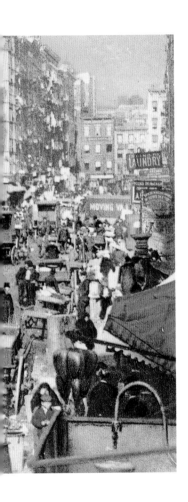

New York is chaos.

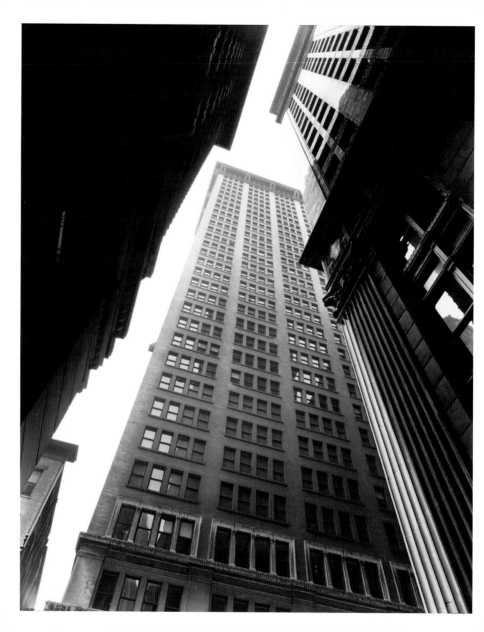

New York is overhead,

Canyon, Broadway and Exchange Place
Berenice Abbott, American, 1898–1991
Gelatin silver print, 9⅝ × 7⅝ in., 1936
Gift of Joyce and Robert Menschel, 1991 1991.1045.1
© Berenice Abbott / Commerce Graphics, Ltd. Inc.,
courtesy Howard Greenberg Gallery, New York

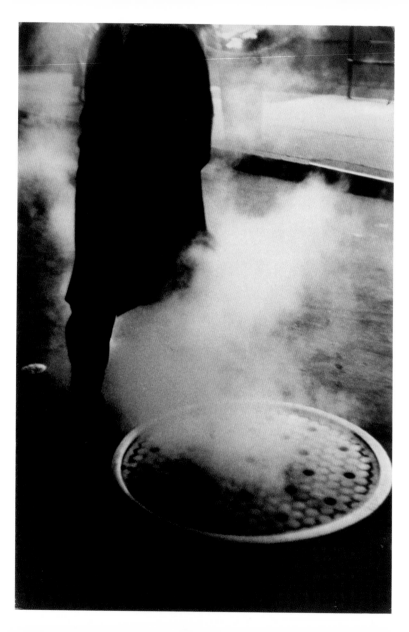

New York is underfoot.

New York is art,

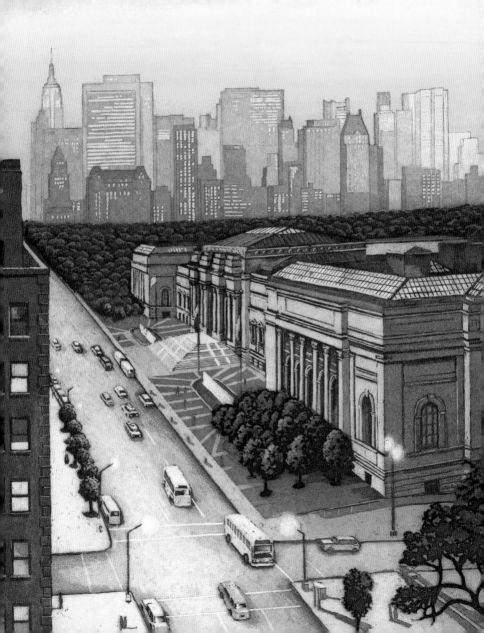

New York is architecture.

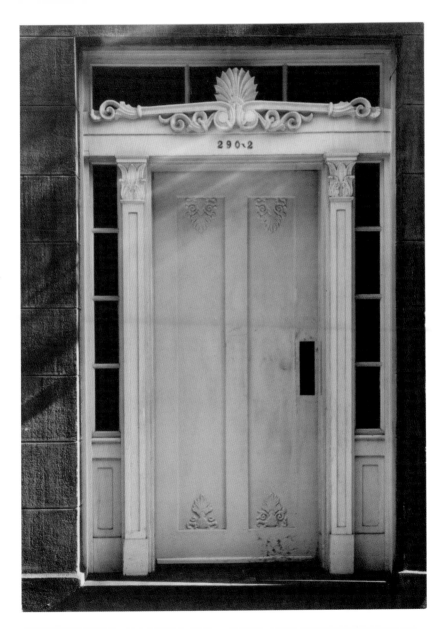

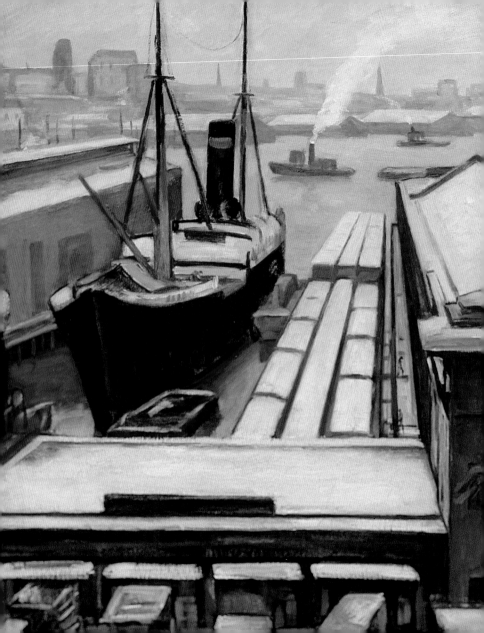

New York is water,

East River (detail)

Samuel Halpert, American, 1884–1930

Oil on canvas, 30¹/₈ × 34¹/₈ in., 1913–14

Gift of Dr. Wesley and Mrs. Carolyn M. Halpert,

in honor of Olga Raggio, 1999 1999.426

New York is steel.

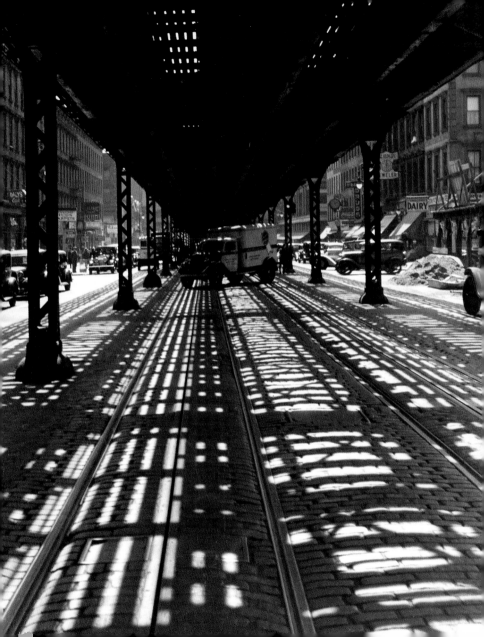

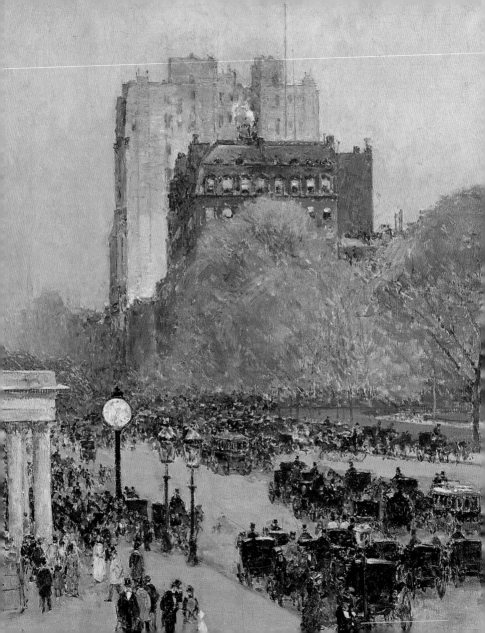

New York is lively,

New York is idyllic.

Spring in Central Park
Adolf Dehn, American, 1895–1968
Watercolor on paper, 17⁷/₈ × 27¹/₄ in., 1941
Fletcher Fund, 1941 41.113ab

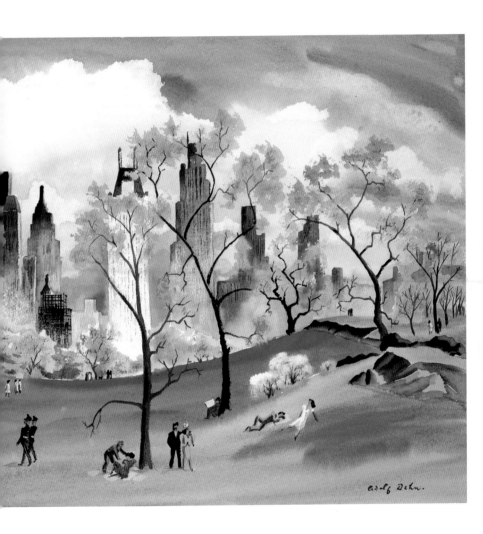

New York is gilded,

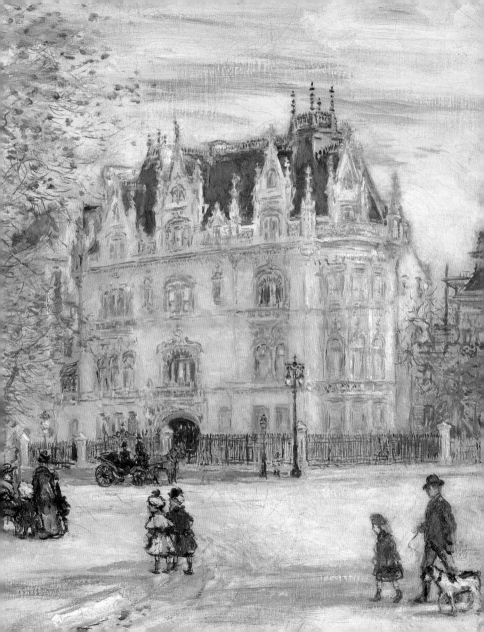

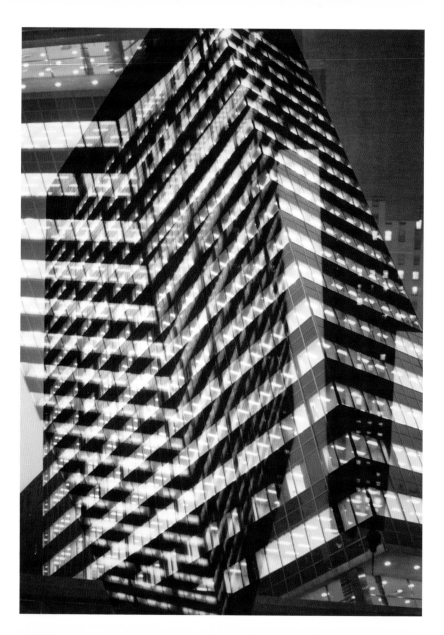

New York is unadorned.

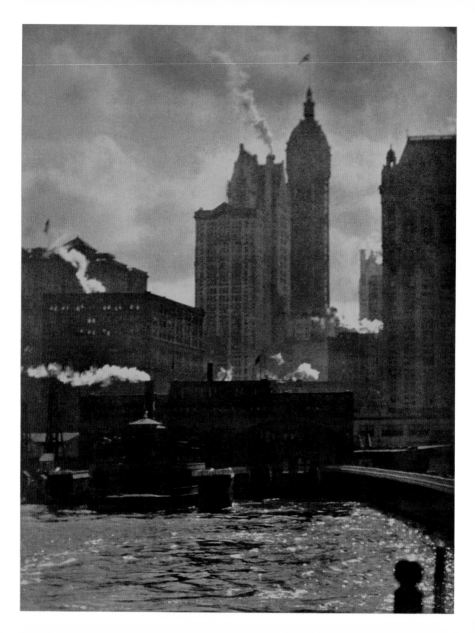

New York is ambition,

New York is chance.

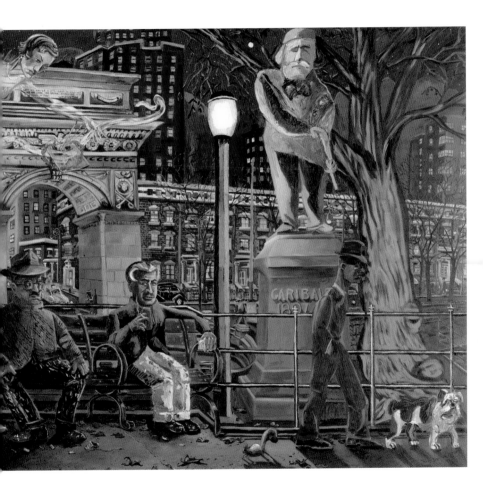

New York is drawn,

New York City

John Marin, American, 1870–1953

Graphite on paper, 4⁵/₈ × 4¹/₄ in., 1932

Alfred Stieglitz Collection, 1949 49.70.150

© Artists Rights Society (ARS), New York

New York is painted.

Union Square, Looking up Park Avenue
Fairfield Porter, American, 1907–1975
Oil on canvas, 62$^1/_4$ × 72 in., 1975
Gift of Mrs. Fairfield Porter, 1978 1978.224

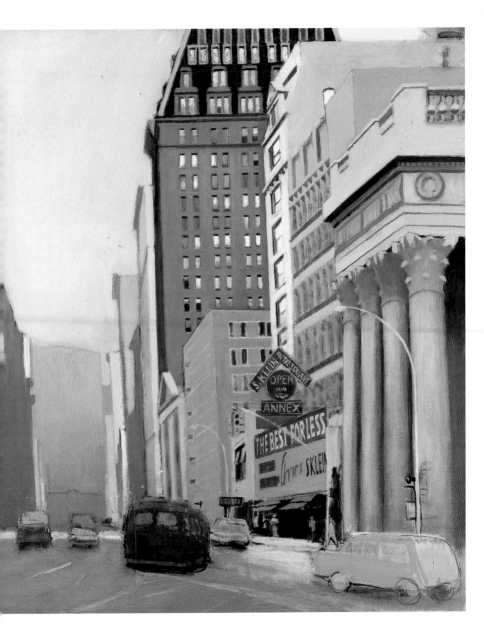

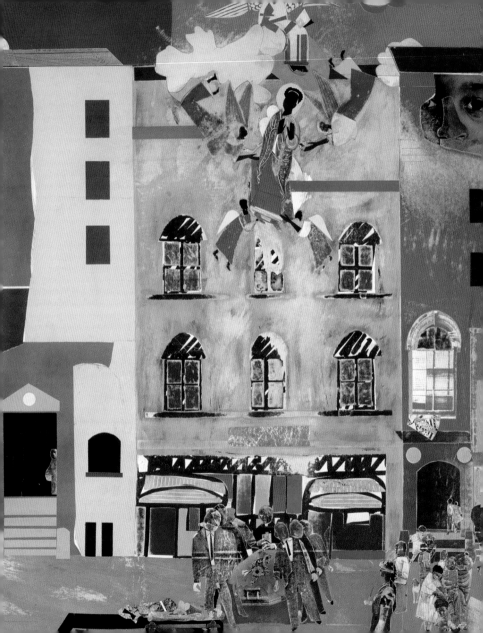

New York is community,

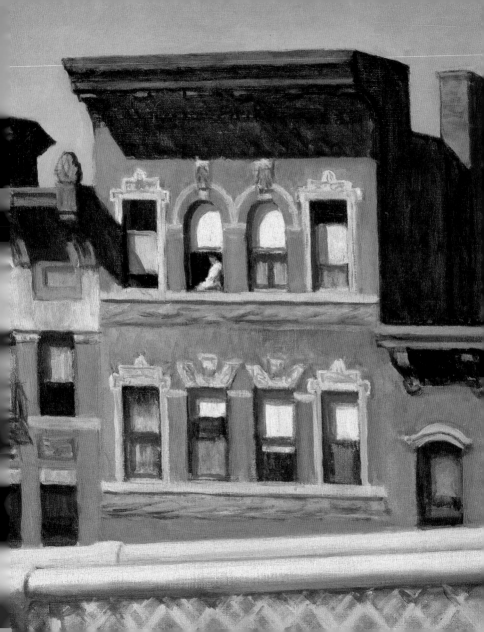

New York is solitude.

New York is glistening,

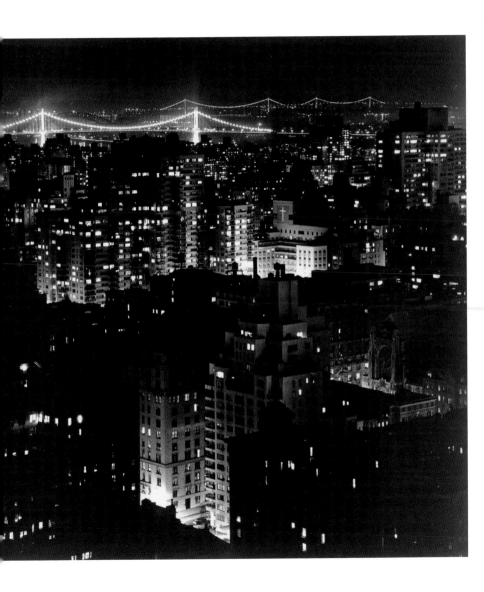

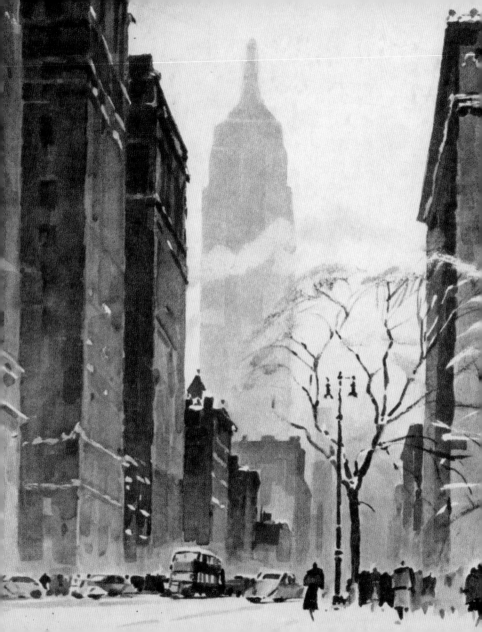

New York is subdued.

New York is fleeting,

Central Park, Winter
William James Glackens, American, 1870–1938
Oil on canvas, 25 × 30 in., ca. 1905
George A. Hearn Fund, 1921 21.164

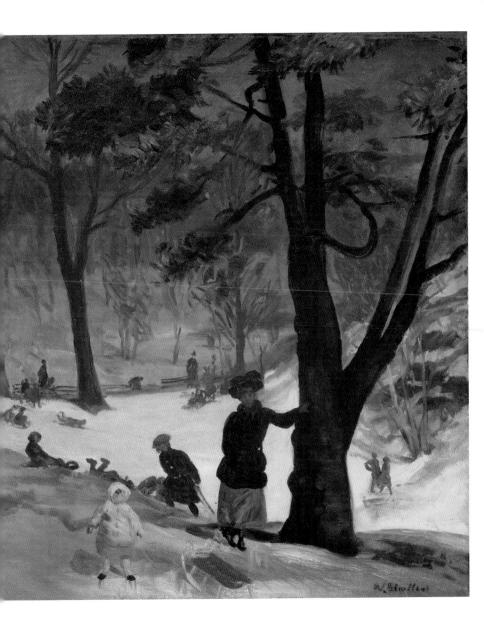

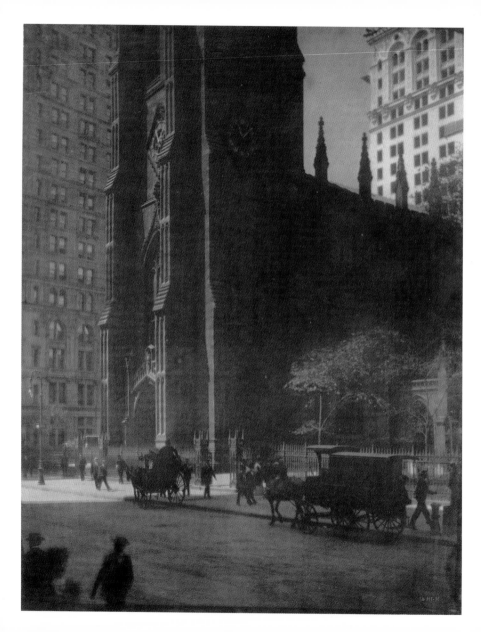

New York is enduring.

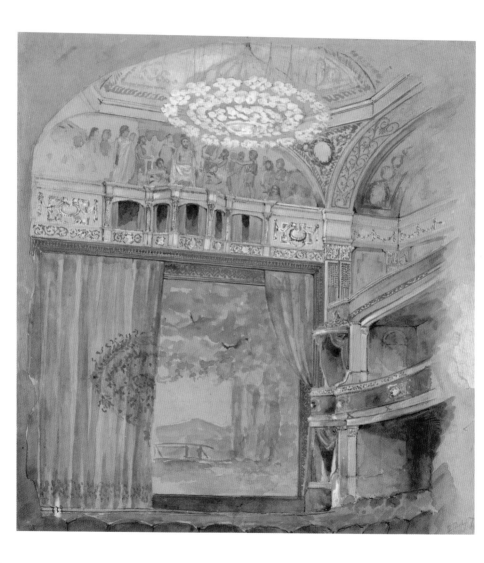

New York is on stage,

New York is on film.

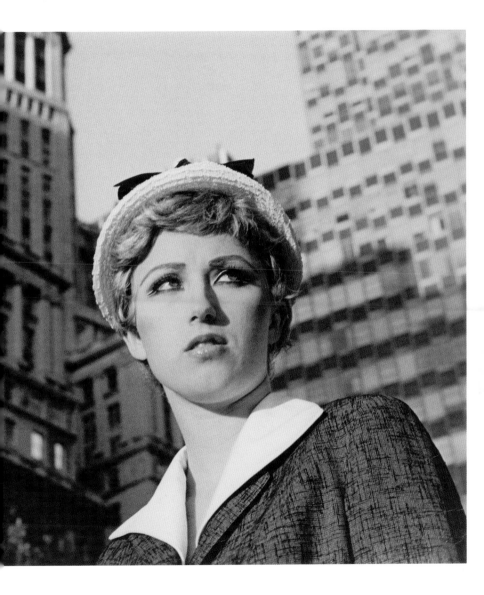

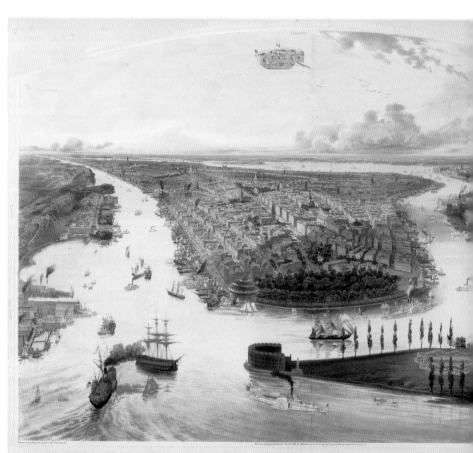

THE EMPIRE CITY,
Birdseye view of NEW-YORK and Environs.

New York is distinctive,

The Empire City, Birdseye View of New York and Environs
John Bachmann, American (b. Germany or Switzerland), active 1849–1885
Printed by Adam Weingartner; published by L. W. Schmidt
Lithograph printed in colors with hand coloring, 28¹/₈ × 38¹/₄ in., 1855
The Edward W. C. Arnold Collection of New York Prints, Maps, and Pictures,
Bequest of Edward W. C. Arnold, 1954 54.90.1198

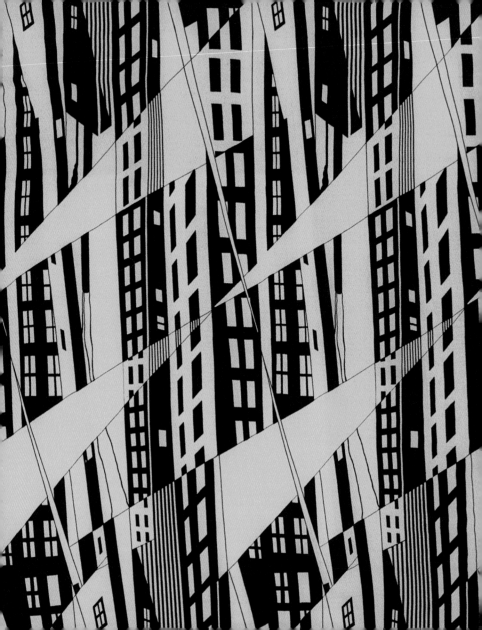

New York is repetition.

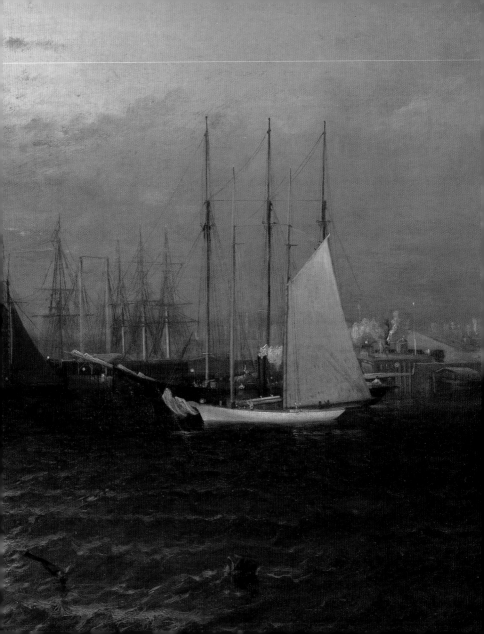

New York is the sea,

New York is the sky.

New York is inspiring,

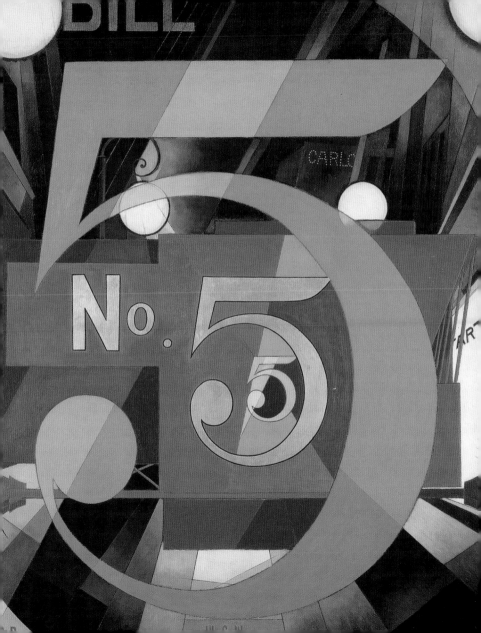

New York is exhausting.

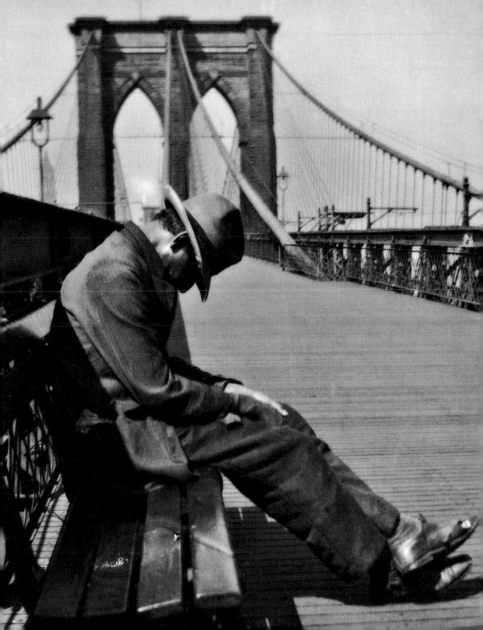

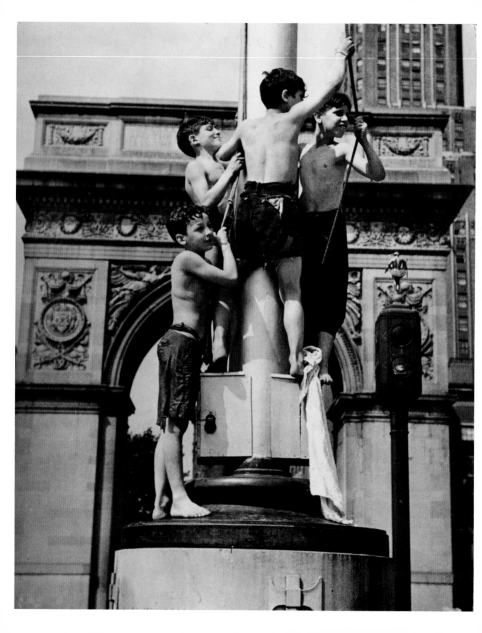

New York is joyous,

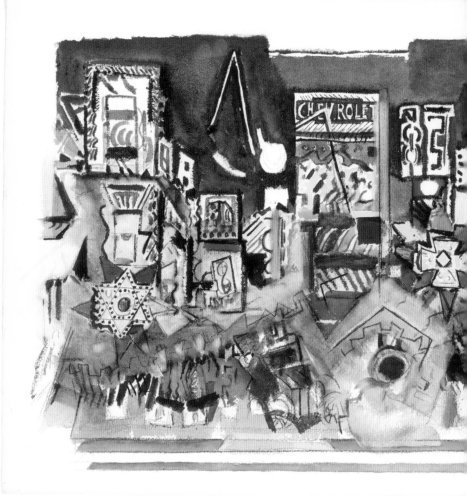

New York is sensational.

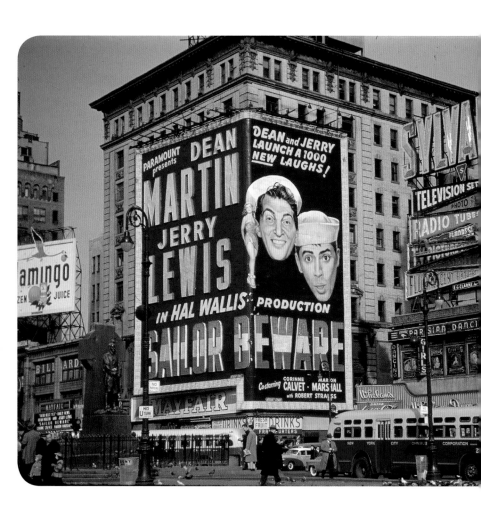

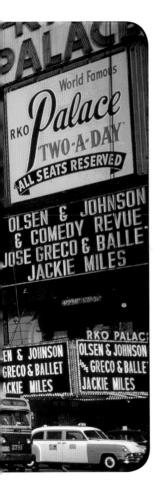

New York is famous,

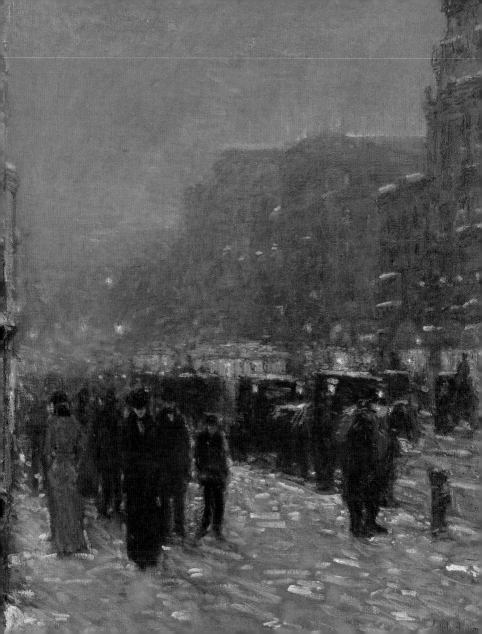

New York is anonymous.

New York is fashion,

New York is design.

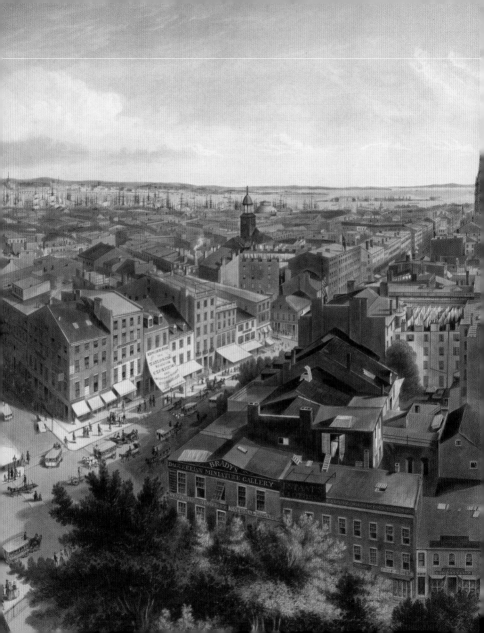

New York is expansive,

New York is confining.

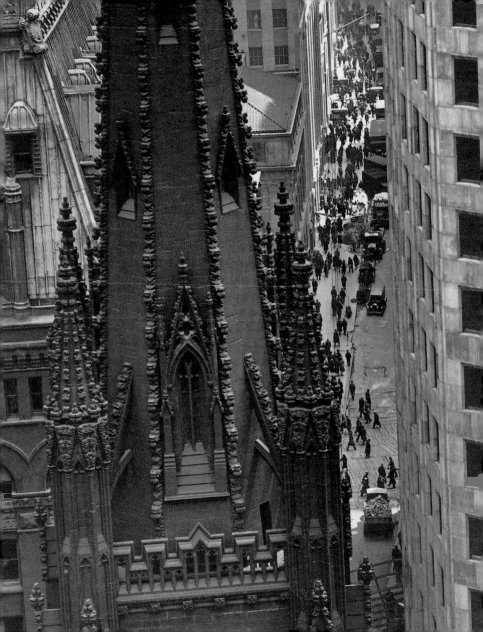

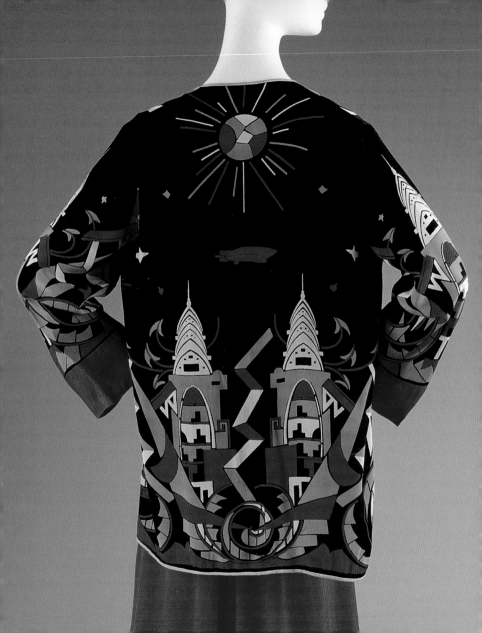

New York is sewn,

New York is quilted.

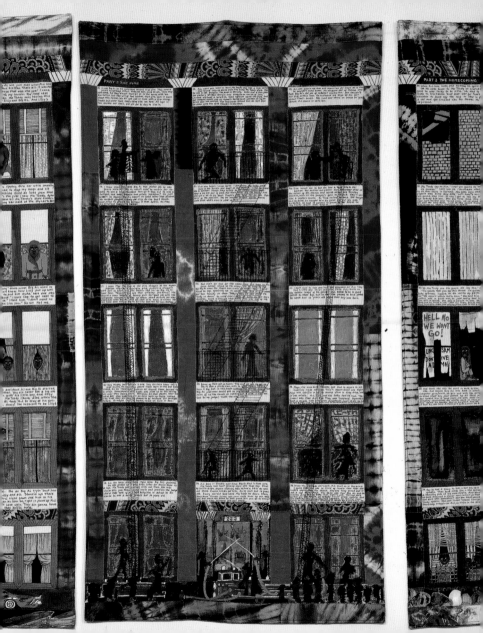

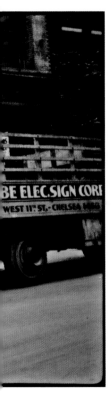

New York is descriptive,

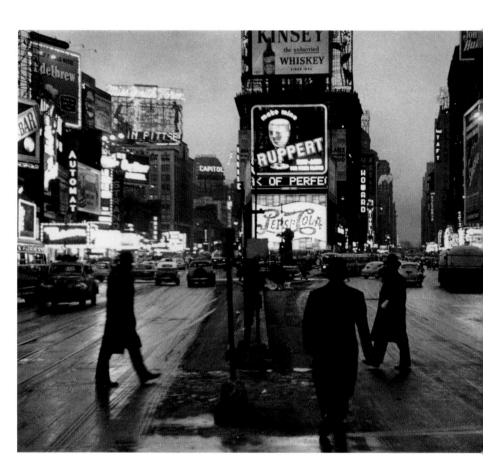

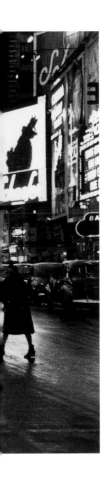

New York is advertising.

New York is dazzling,

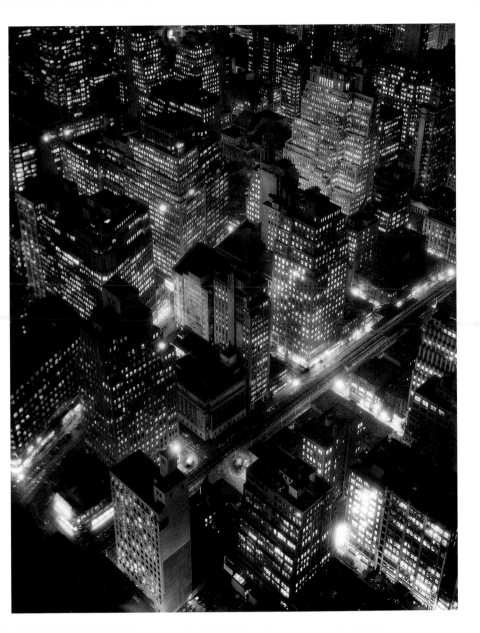

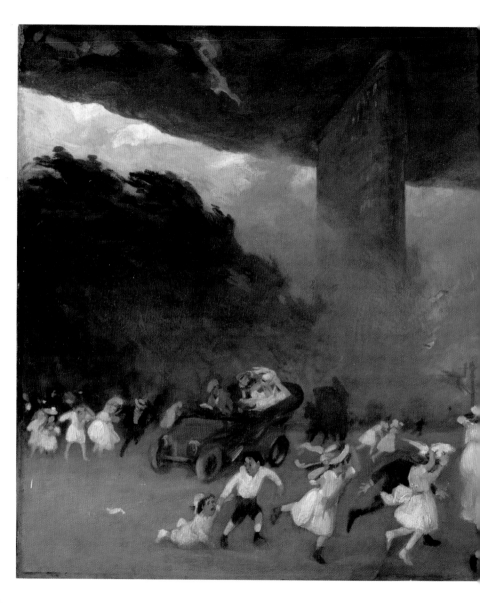

New York is stormy.

New York is food,

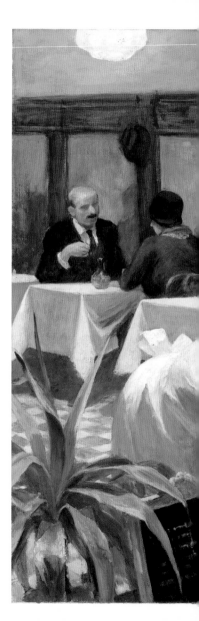

Tables for Ladies
Edward Hopper, American, 1882–1967
Oil on canvas, 48³/₄ × 60¹/₄ in., 1930
George A. Hearn Fund, 1931 31.62

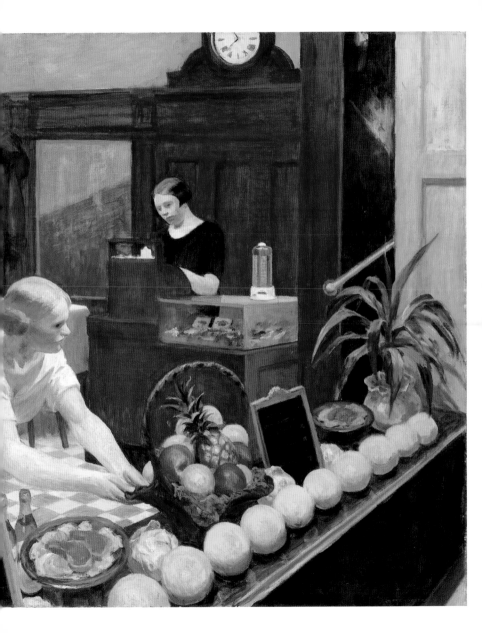

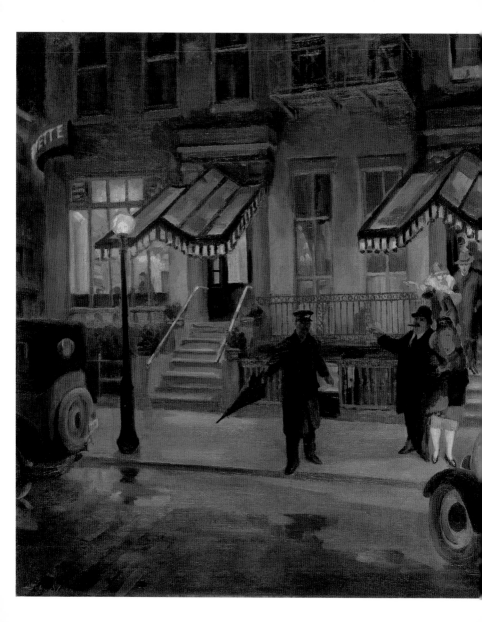

New York is culture.

DESIGN MADE FOR ASTOR'S HOTEL
BY I. TOWN & A. J. DAVIS, ARC'TS.

PLAN BY ITHIEL TOWN, ARC'T.
FOR ASTOR'S HOTEL
NEW-YORK, 1832.

New York is planned,

New York is happenstance.

[Empire State Building Above Brownstone Buildings]
Herbert J. Seligmann, American, 1891–1984
Gelatin silver print, 4 × 2¹³/₁₆ in., 1930s
Ford Motor Company Collection, Gift of Ford Motor Company and John C. Waddell, 1987 1987.1100.473

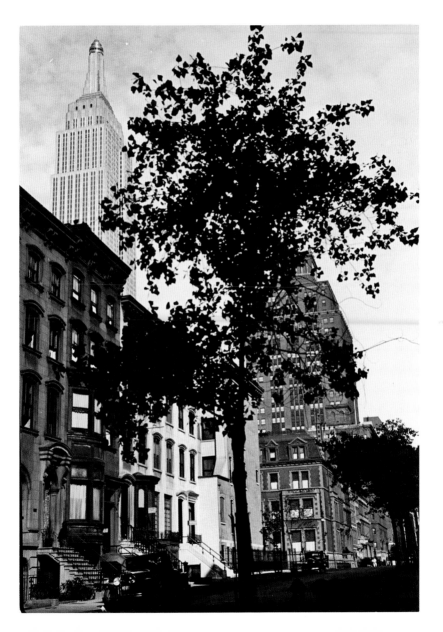

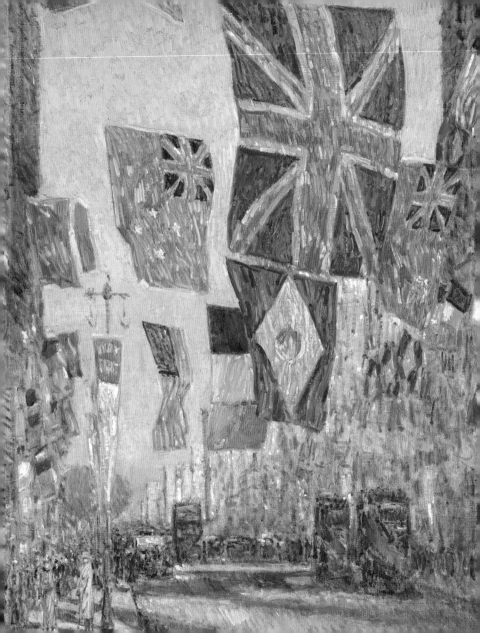

New York is celebration,

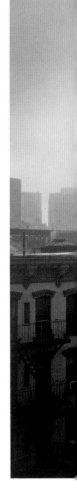

New York is remembrance.

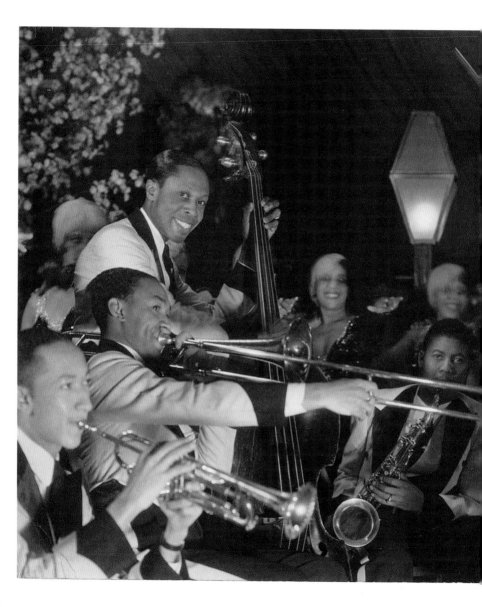

New York is music,

New York is poetry.

EPITAPH

THEODORE DREISER

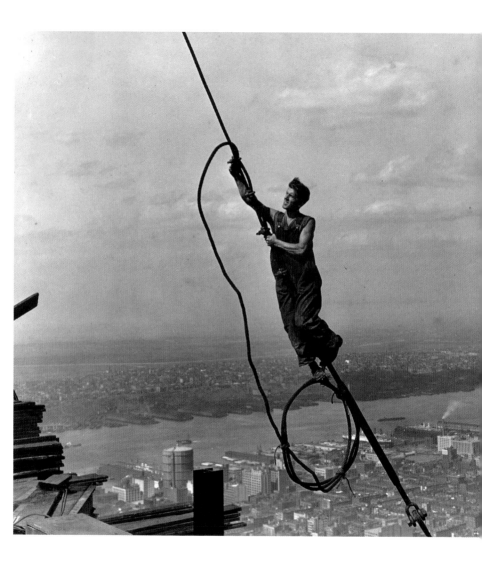

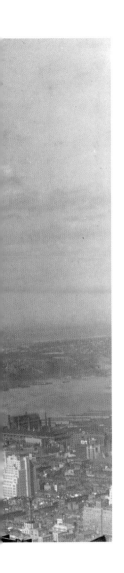

New York is adventure,

Icarus, Empire State Building
Lewis Hine, American, 1874–1940
Gelatin silver print, 7³/₈ × 9⁵/₁₆ in., 1930
Ford Motor Company Collection, Gift of Ford
Motor Company and John C. Waddell, 1987 1987.1100.119

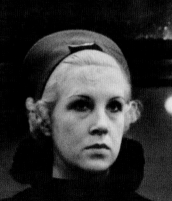

New York is routine.

New York is ephemera,

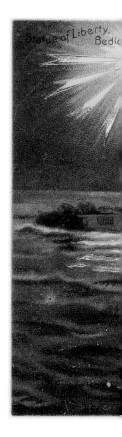

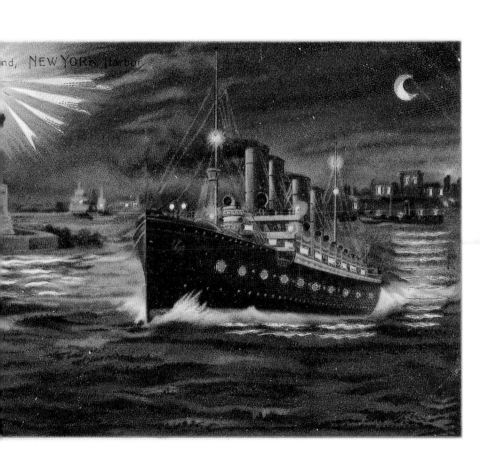
nd, NEW YORK Harbor

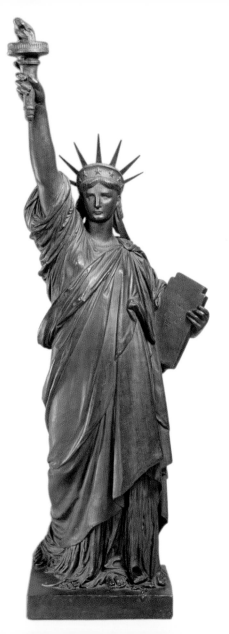

New York is sculpture.

New York is angled,

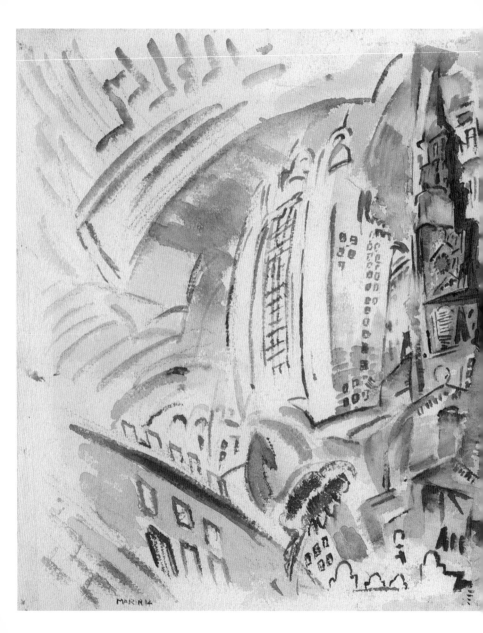

New York is curved.

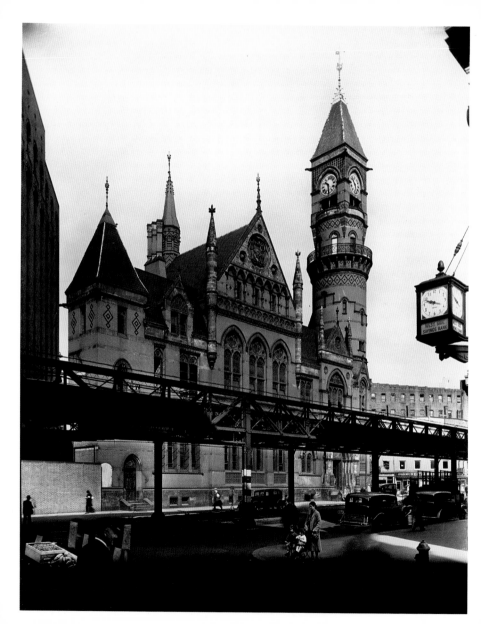

New York is Victorian,

JULY
1928

The
GIFT
AND
ART
SHOP

DESKEY

GEYER PUBLICATIONS
ANDREW GEYER INC. PUBLISHERS
260 FIFTH AVENUE, NEW YORK

New York is Art Deco.

The Gift and Art Shop
Donald Deskey, American, 1894–1989
Printed by Geyer Publications, Andrew Geyer Inc. Publishers
Printed paper, 11 × 8 in., 1928
Anonymous Gift, 1999 1999.432

New York is love,

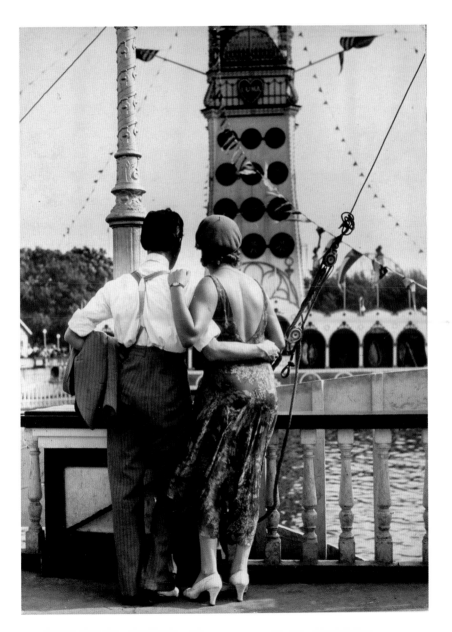

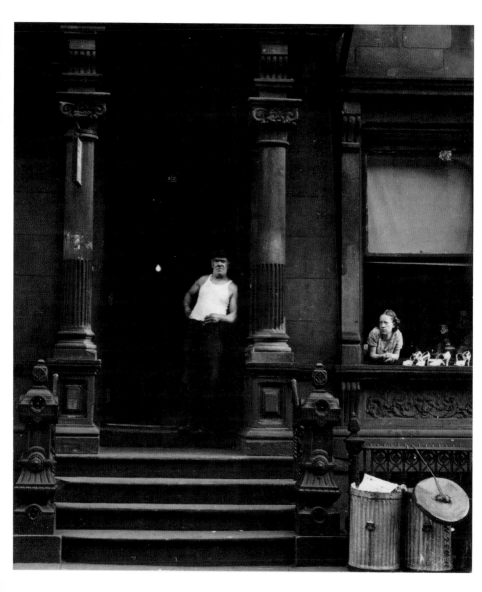

New York is heartbreak.

New York is expressive,

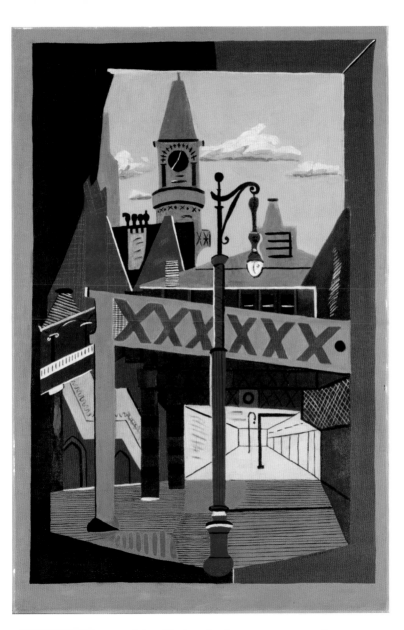

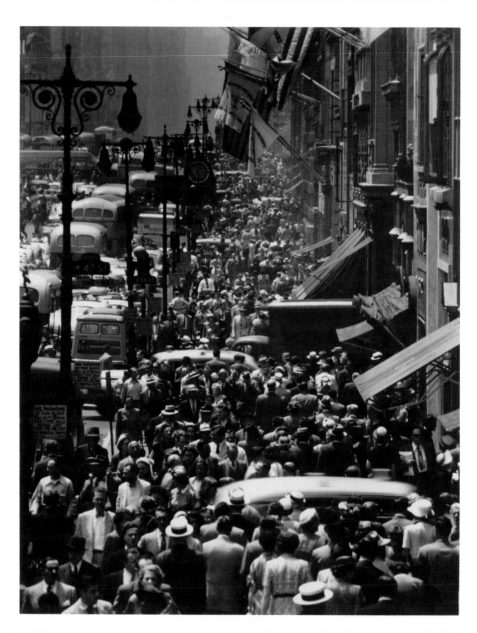

New York is mundane.

New York is edifice,

Metropolitan Life Insurance Building, New York
Published by Detroit Publishing Company, American, 1908–09
Color lithograph, 5 1/2 x 3 1/2 in.
The Jefferson R. Burdick Collection, Gift of Jefferson R. Burdick, Burdick 416, p. 51v(3)

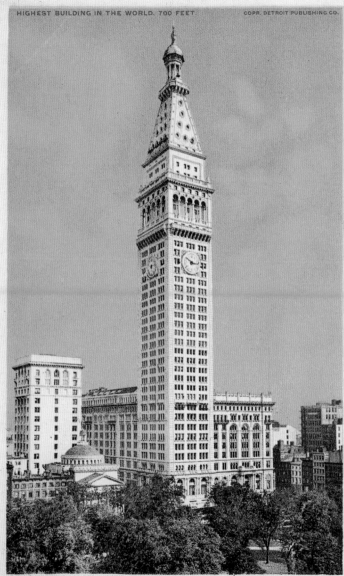

New York is frame.

From My Window at An American Place, Southwest
Alfred Stieglitz, American, 1864–1946
Gelatin silver print, 7⁹/₁₆ × 9¹/₂ in., 1932
Alfred Stieglitz Collection, 1949 49.55.48

New York is festive,

New York is dreary.

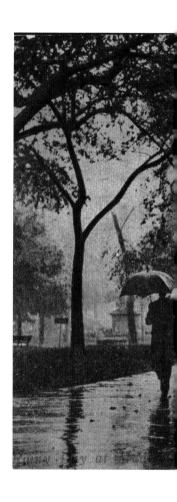

Rainy Day at Madison Square, New York City
American, 1900s–1930s
Photomechanical reproduction, 3⁹/₁₆ x 5¹/₂ in.
Walker Evans Archive, 1994 1994.264.107.575

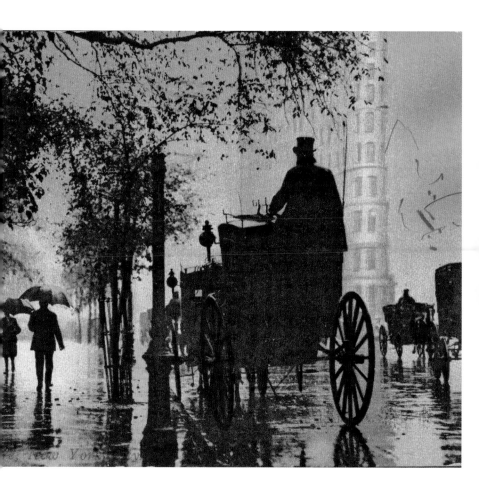

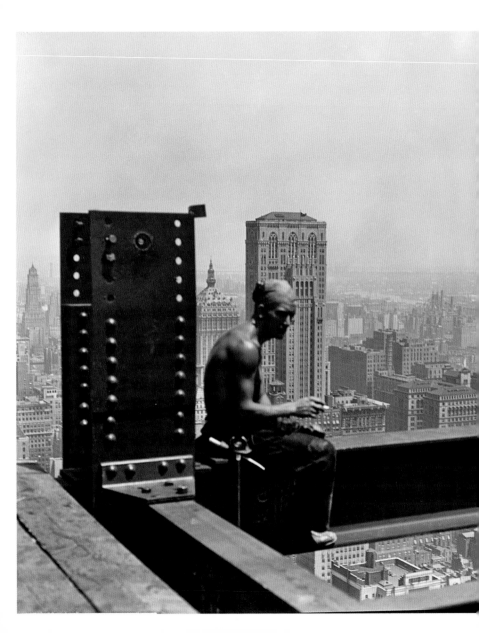

New York is built,

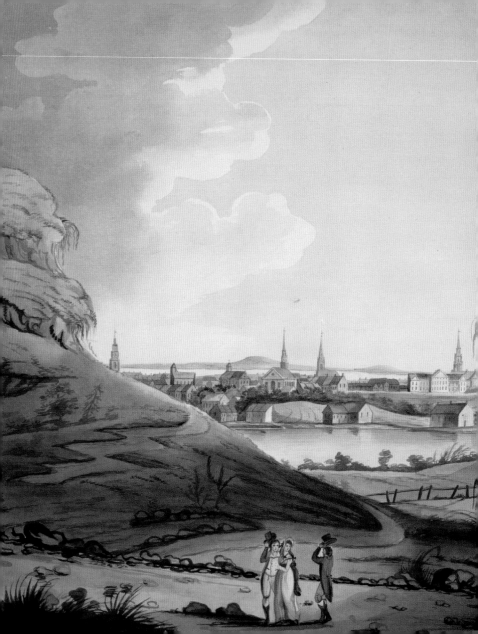

New York is natural.

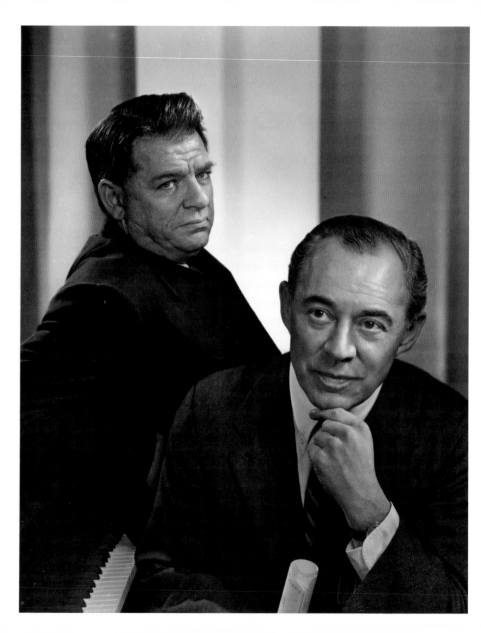

New York is song,

New York is dance.

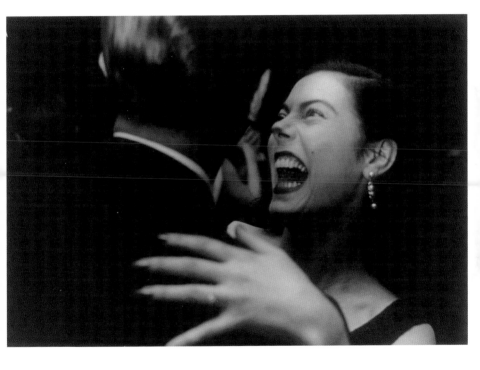

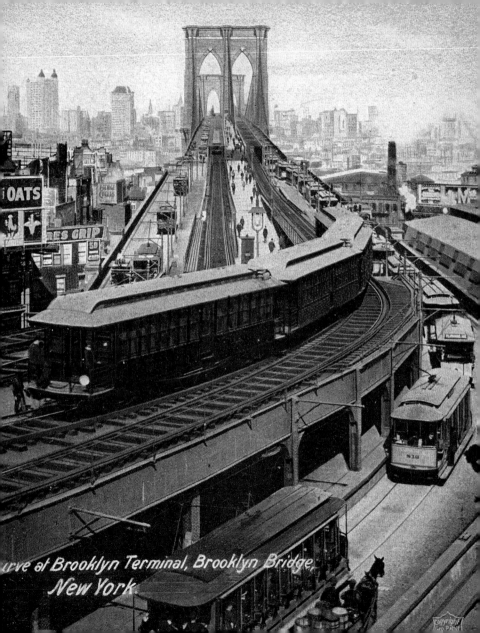

Curve at Brooklyn Terminal, Brooklyn Bridge, New York

New York is trains,

New York is automobiles.

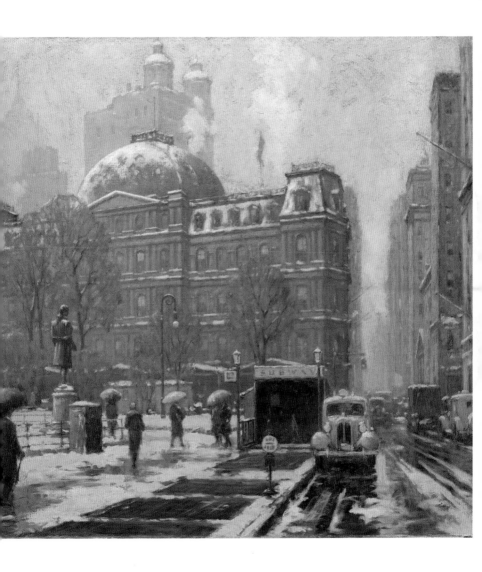

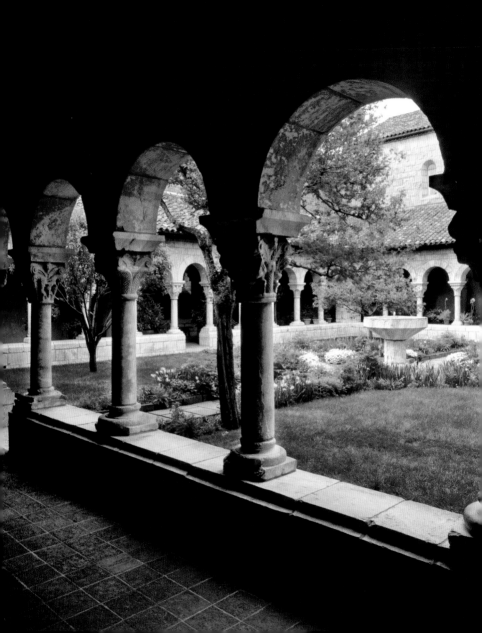

New York is stone,

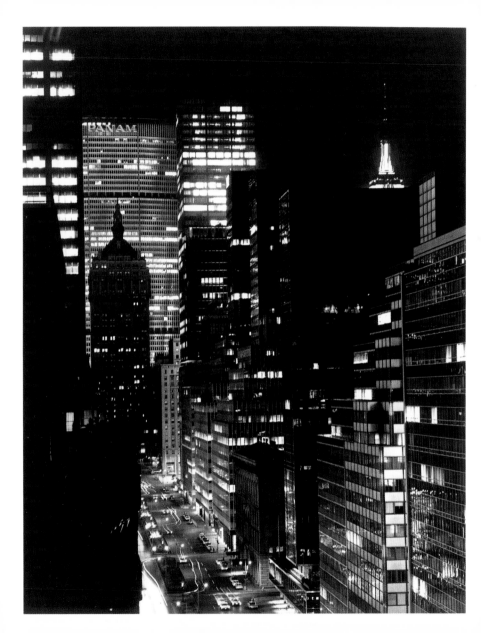

New York is glass.

New York is a moment,

Financial District, from the Hotel Bossert
Samuel H. Gottscho, American, 1875–1971
Gelatin silver print, 6⁹/₁₆ × 9⁷/₁₆ in., 1933, printed later
Purchase, Florance Waterbury Bequest, 1970 1970.660.11

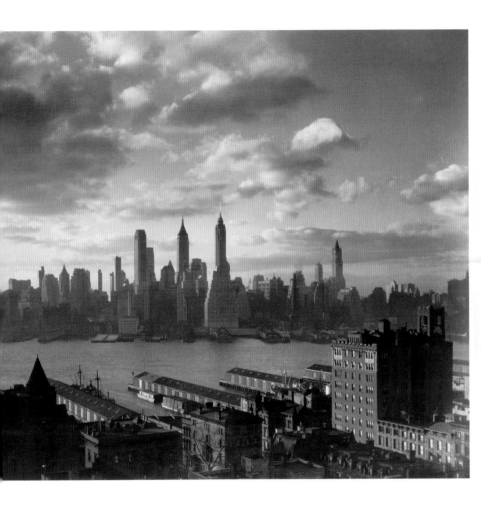

New York is an impression.

Winter in Union Square (detail)
Childe Hassam, American, 1859–1935
Oil on canvas, 18¹/₄ × 18 in., 1889–90
Gift of Ethelyn McKinney, in memory of her brother, Glenn Ford McKinney, 1943 43.116.2

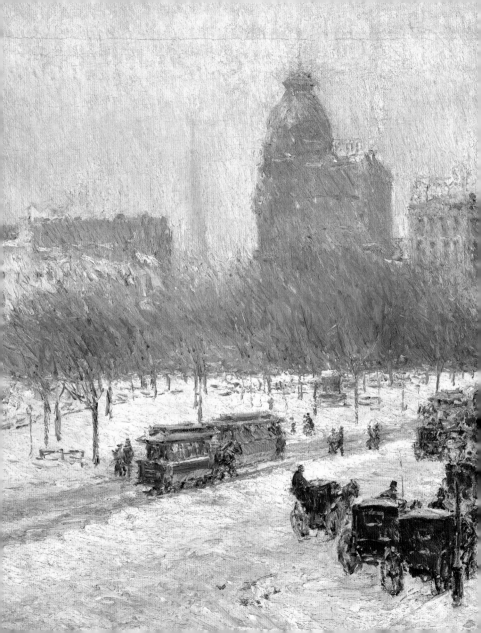

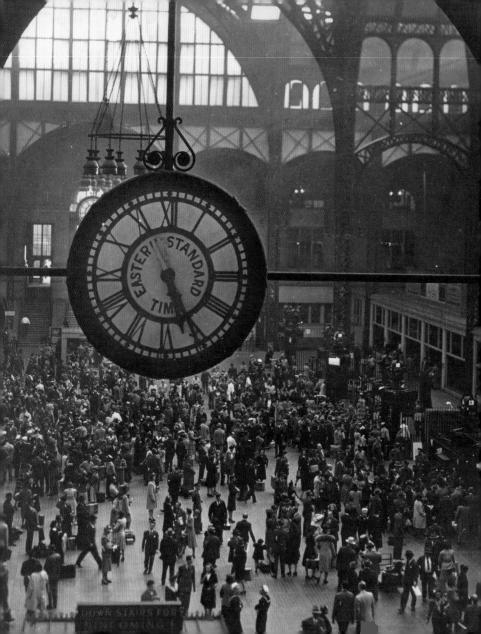

New York is bustling,

New York is deserted.

New York is law,

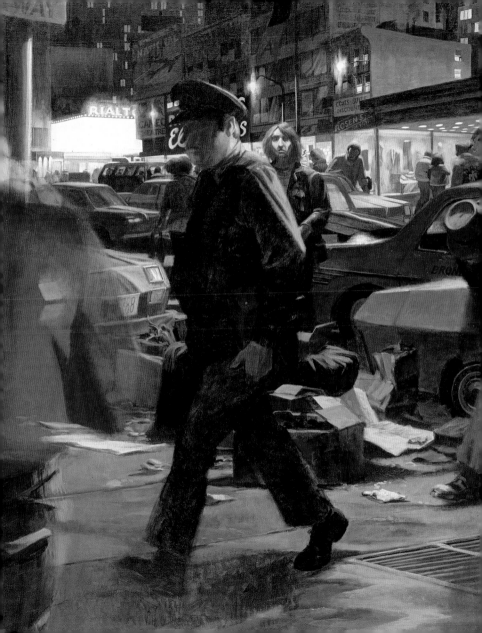

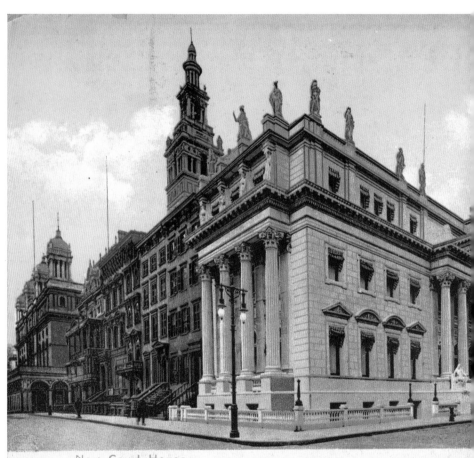

New Court House.

New York is order.

New Court House, New York
American, 1900–1930s
Photomechanical reproduction, 3⁹/₁₆ × 5¹/₂ in.
Walker Evans Archive, 1994 1994.264.33.38

New York is daring,

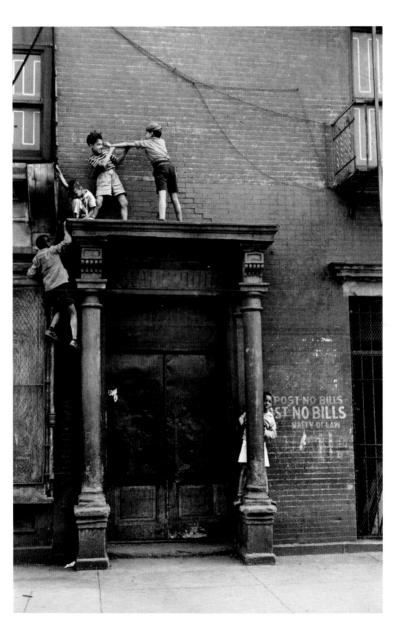

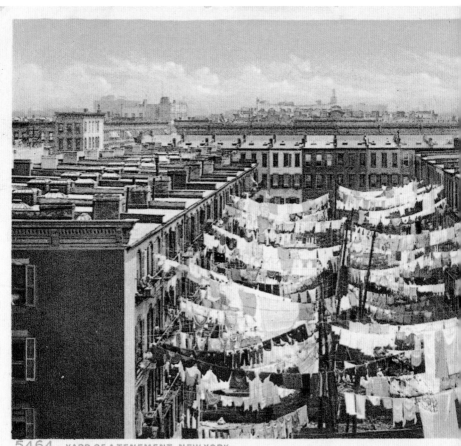

5464 YARD OF A TENEMENT, NEW YORK.

New York is banal.

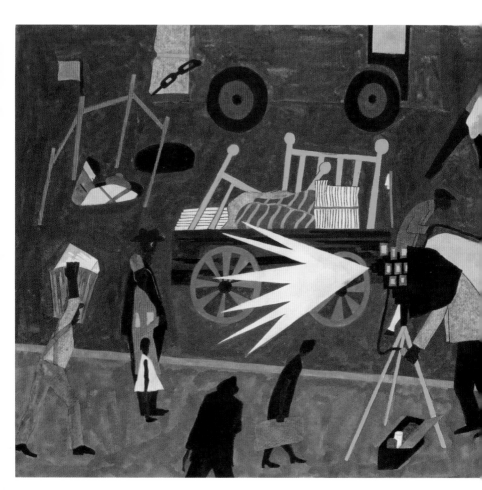

New York is streetscape,

New York is landscape.

Pine Bank Arch, Central Park
John Hall, American, b. 1952
Gelatin silver print, 10⁹/₁₆ × 13¹/₈ in., 1996
Purchase, Charina Foundation Inc. Gift, 1998 1998.224
© John Hall

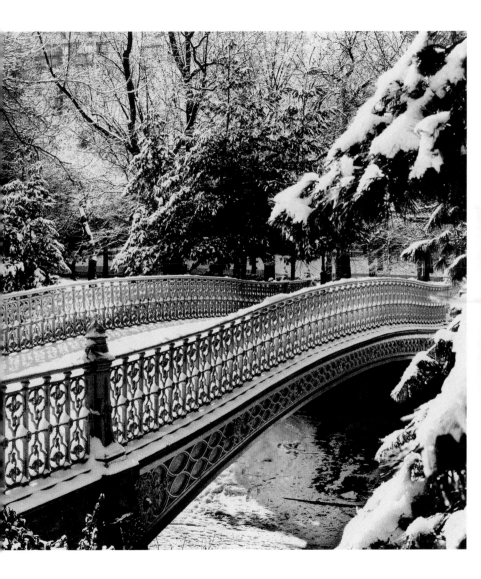

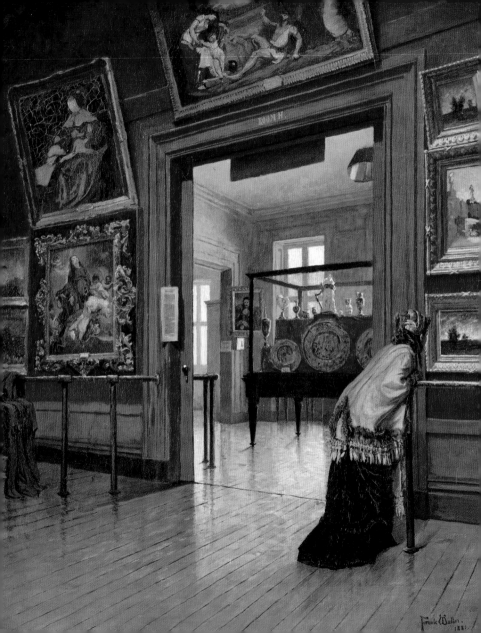

ROOM H.

Frank Walker
1881

New York is observation,

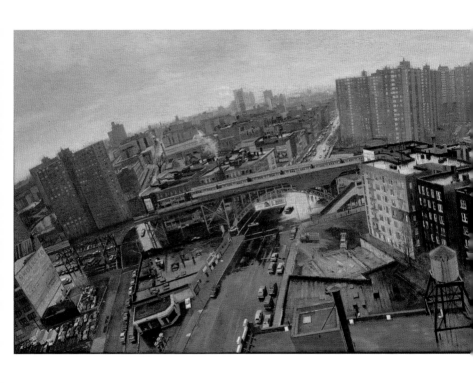

New York is perspective.

New York is posh,

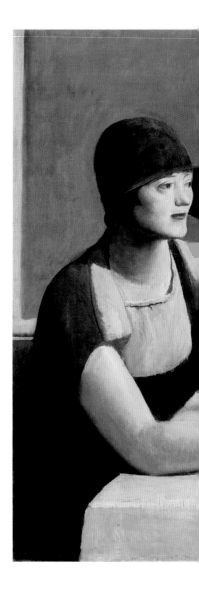

Mr. and Mrs. Chester Dale Dine Out
Guy Pène du Bois, American, 1884–1958
Oil on canvas, 30 × 40 in., 1924
Gift of Chester Dale, 1963 63.138.1

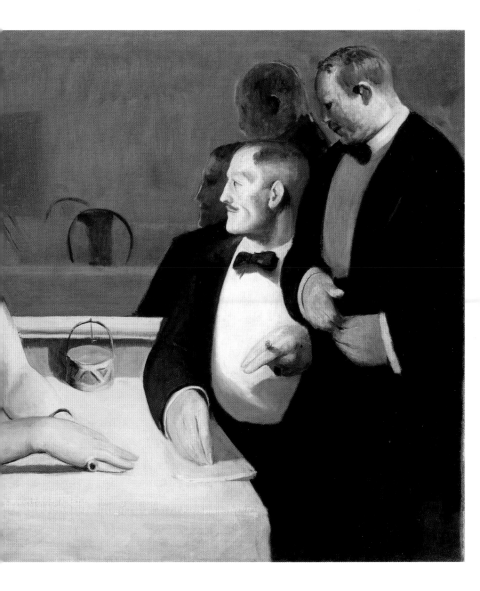

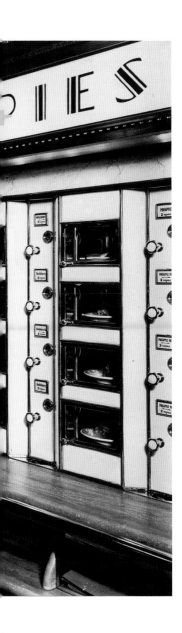

New York is spare.

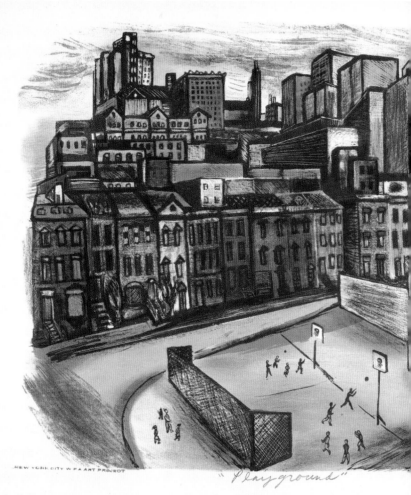

"Playground"

New York is play,

Playground
Ruth Chaney, American, b. 1908
Published by the Works Progress Administration
Serigraph, 13 × 9³/₄ in., 1935–43
Gift of the Works Progress Administration, New York, 1943 43.33.832

New York is study.

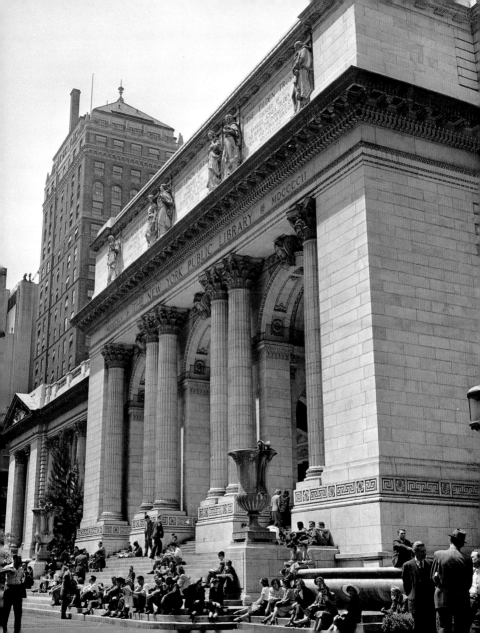

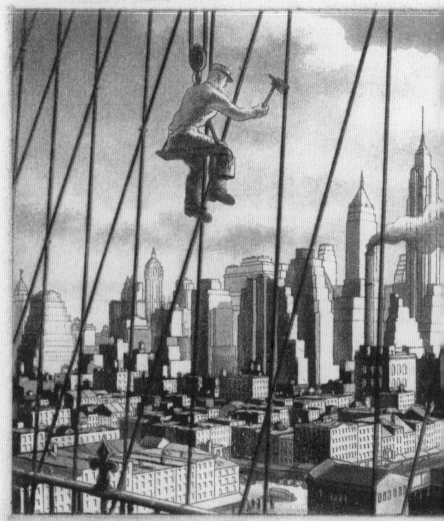

"Babylon"

New York is drafted,

New York is acted.

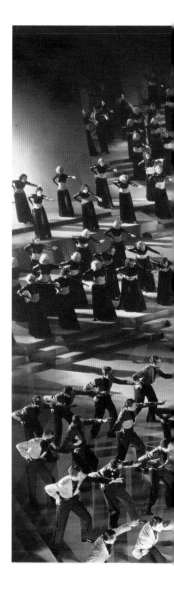

"Lullaby of Broadway" from Gold Diggers of 1935

American, 1935

Gelatin silver print, 7¹/₂ × 9⁵/₈ in.

Ford Motor Company Collection, Gift of Ford Motor Company

and John C. Waddell, 1987 1987.1100.142

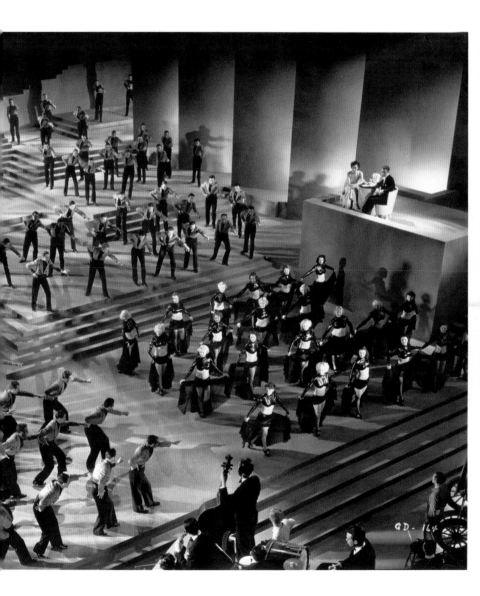

GD-164

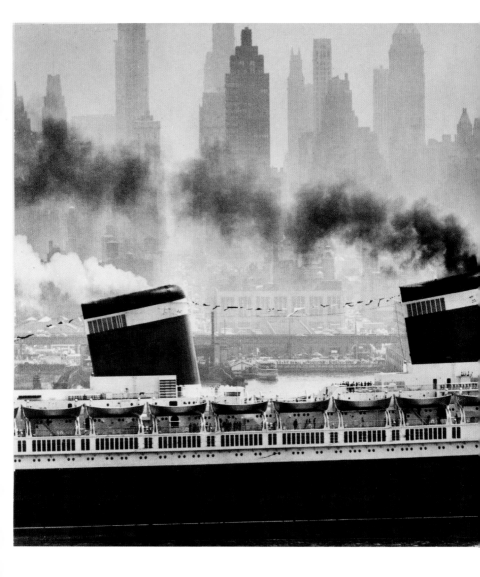

New York is a voyage,

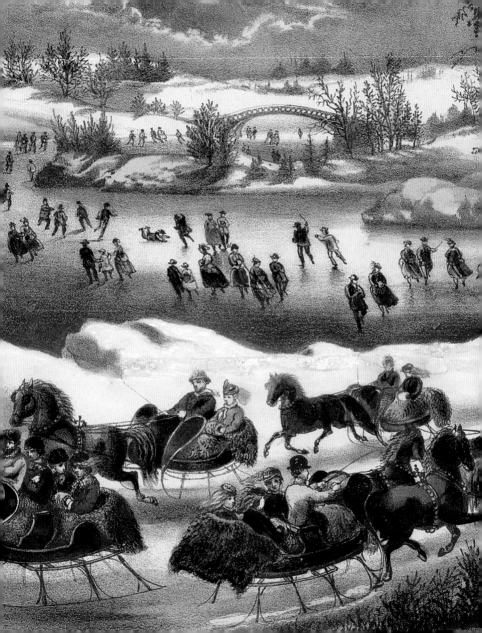

New York is a jaunt.

New York is real,

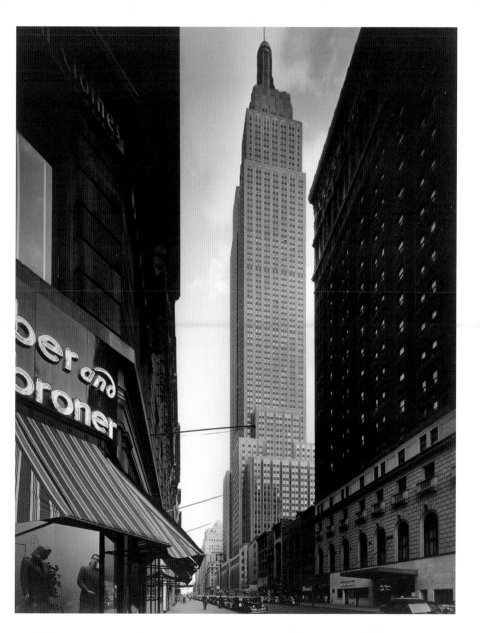

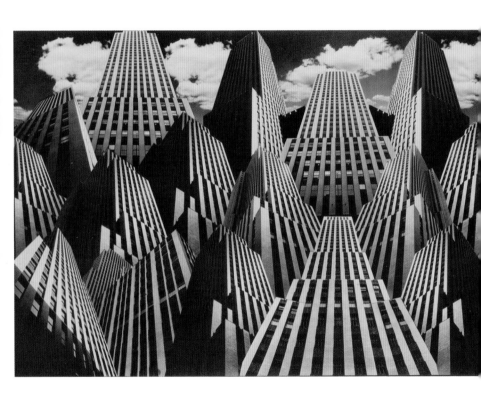

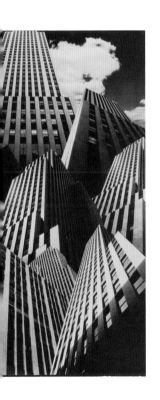

New York is illusion.

Skyscrapers
Thurman Rotan, American, 1903–1991
Gelatin silver print, 8³/₁₆ × 16¹/₁₆ in., 1932
Ford Motor Company Collection, Gift of Ford Motor Company
and John C. Waddell, 1987 1987.1100.280

New York is energetic,

Queensboro Bridge at Night
Joseph W. Golinkin, American, 1896–1977
Published by American Artists Group
Commercial photomechanical process, 6 × 4¹/₄ in.
The Jefferson R. Burdick Collection, Gift of Jefferson R. Burdick, Burdick 574, p. 87

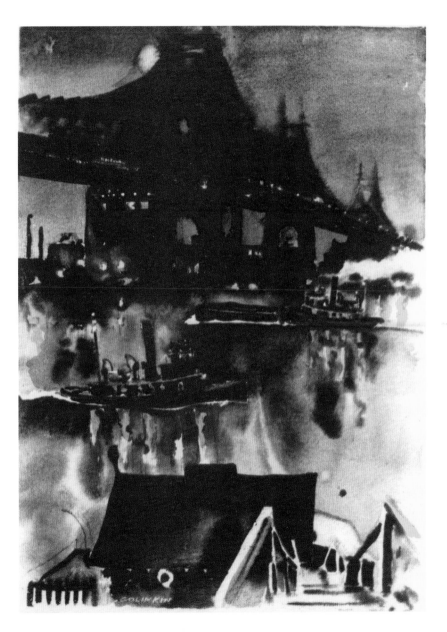

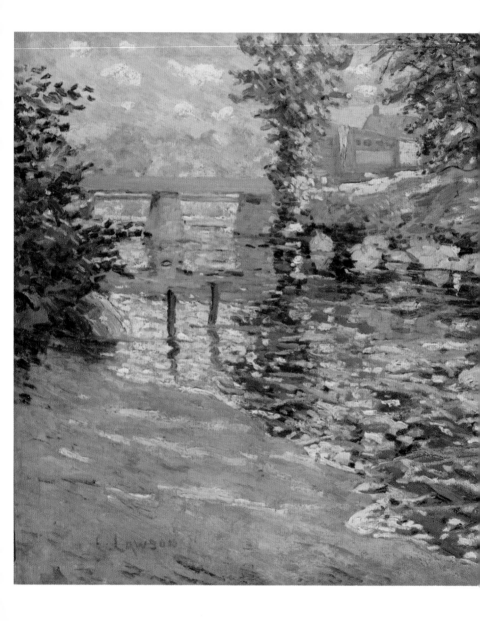

New York is tranquil.

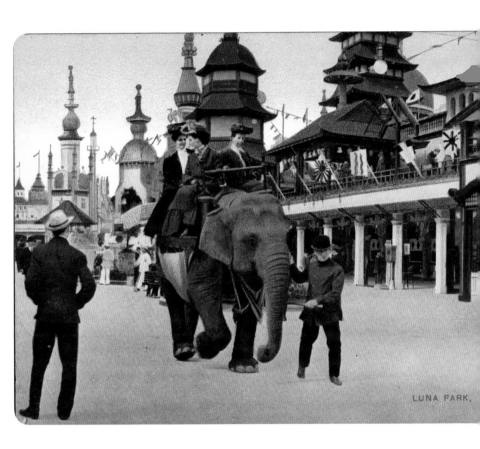

LUNA PARK,

EY ISLAND.

New York is amusement,

New York is exertion.

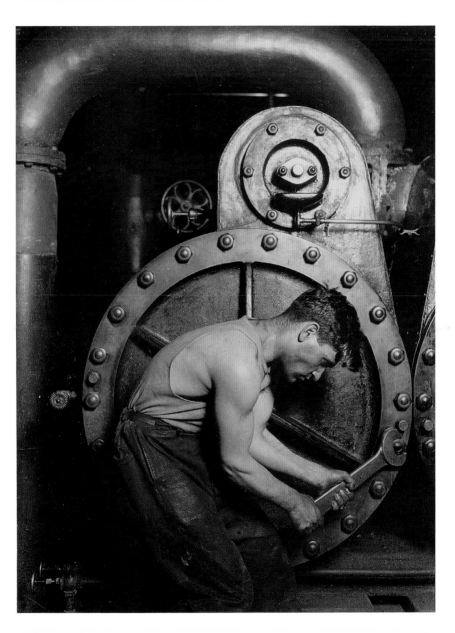

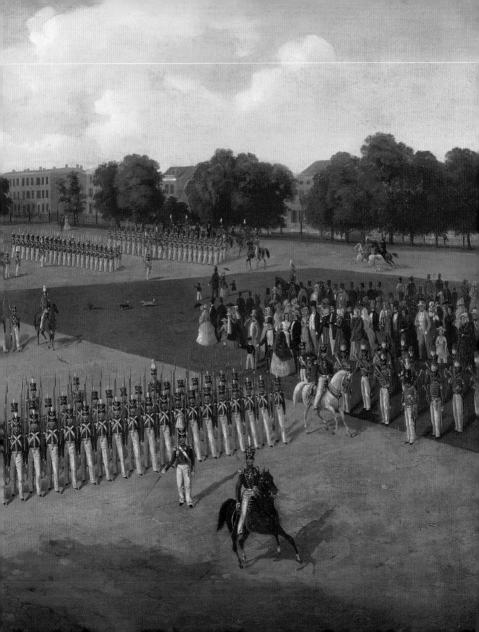

New York is history,

New York is vision.

Trylon and Perisphere, New York World's Fair
Samuel H. Gottscho, American, 1875–1971
Gelatin silver print, 13 × 8 1/2 in., ca. 1939
Ford Motor Company Collection, Gift of Ford Motor Company
and John C. Waddell, 1987 1987.1100.404

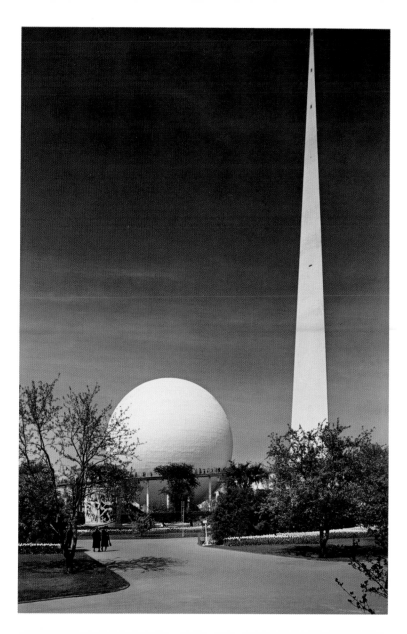

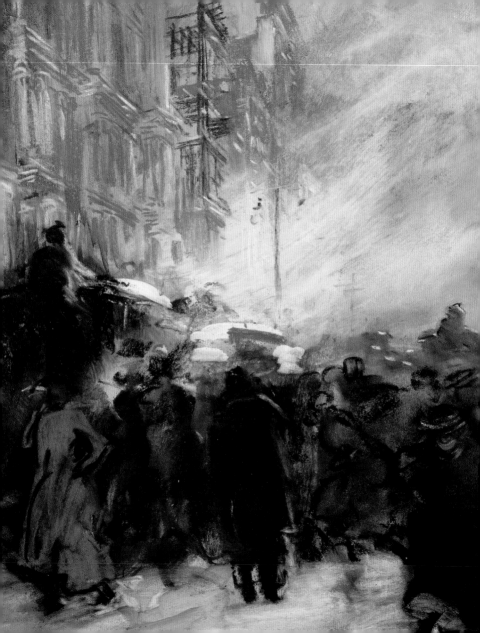

New York is evocative,

New York is reflection.

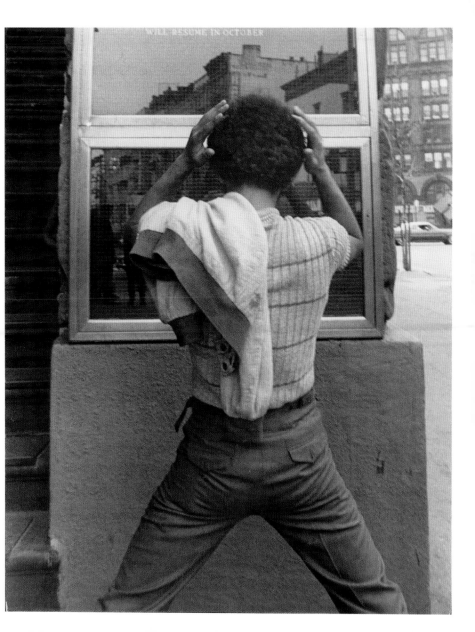

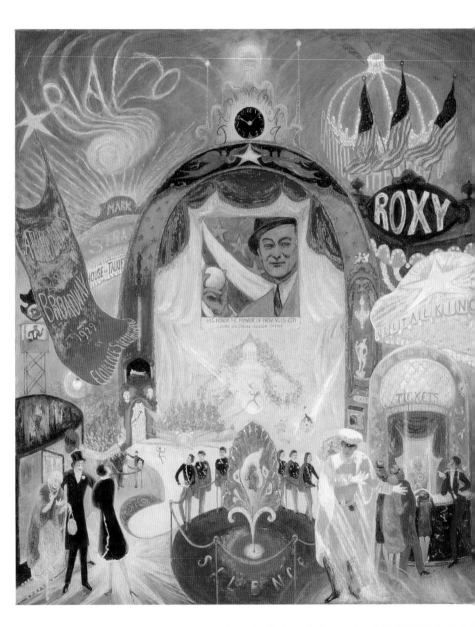

New York is performance,

New York is sport.

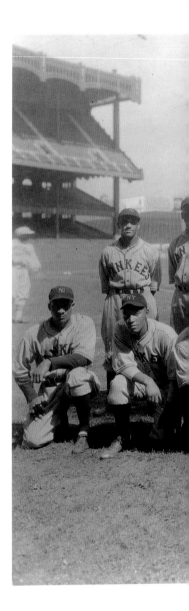

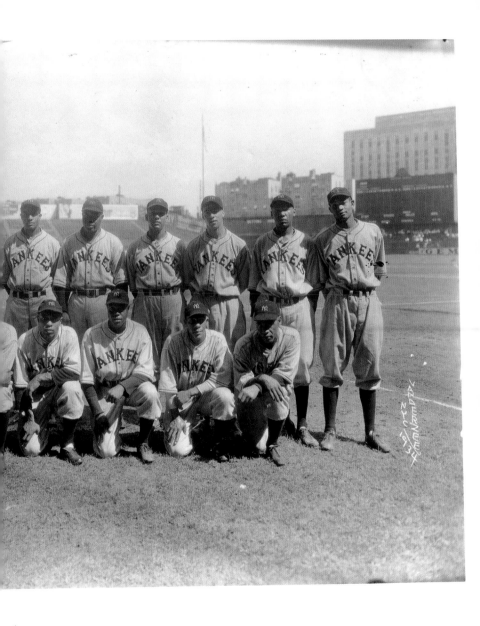

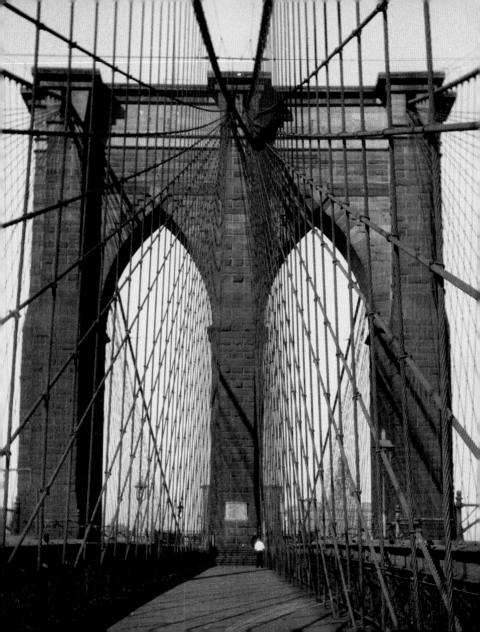

New York is symmetry,

New York is juxtaposition.

South Street Bridge
Dong Kingman, American, 1911–2000
Watercolor on paper, 21 1/2 × 29 3/4 in., 1955
George A. Hearn Fund, 1955 55.101

New York is monumental,

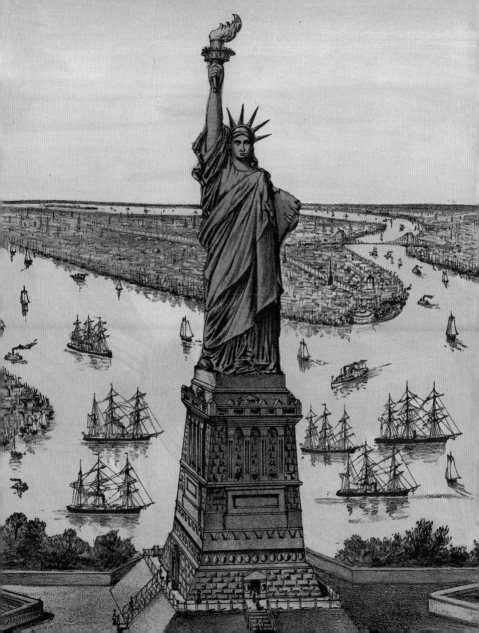

New York is ordinary.

Daily News
Dona Nelson, American, b. 1952
Oil on canvas, 84 × 60 in., 1983
Purchase, Emma P. Ziprik Memorial Fund Gift,
in memory of Fred and Emma P. Ziprik, 1984 1984.266

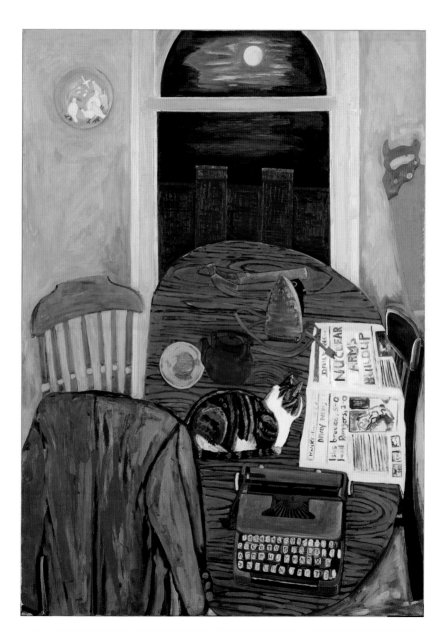

New York is by foot,

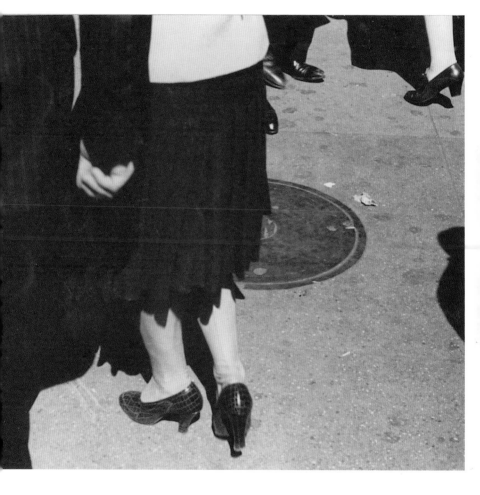

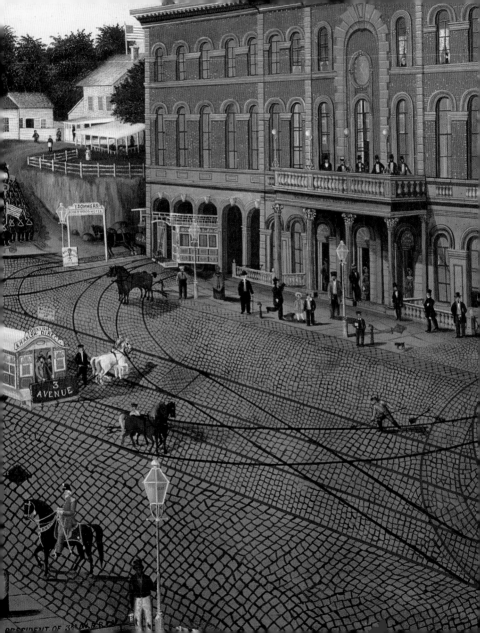

New York is by hoof.

New York is green space,

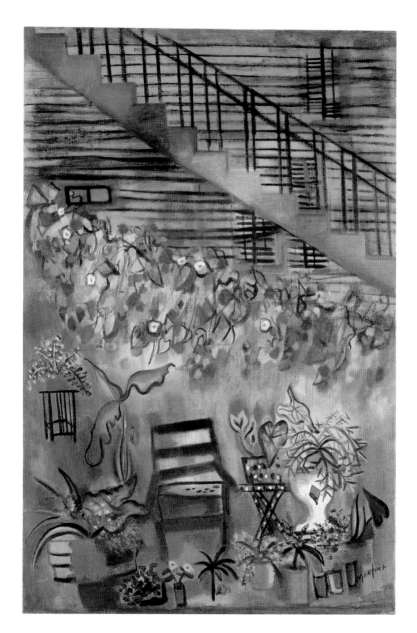

New York is pavement.

New York is angelic,

New York is trouble.

New York is brownstone,

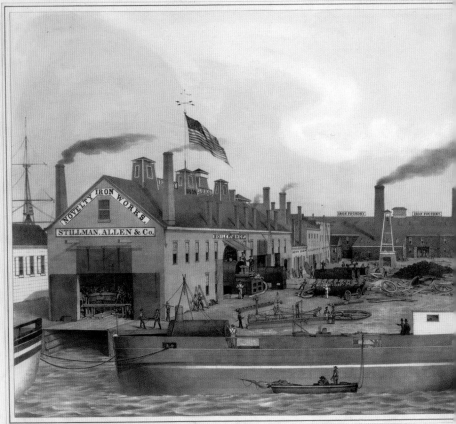

NOVELTY IRON WORKS, FOOT OF 12th ST.

STILLMAN, ALLEN & Co.

Steam Boilers, Iron Ships and Boats, Sugar Mills, Wrought Iron Sugar Kettles, Improved Steam Clarifiers and Evaporators Vacuum Pans, Hydraulic.

Iron Founders Steam Engine and General Machinery Manufacturers.

Novelty Iron Works, Foot of 12th St. E. R. New York.

NEW YORK.

*Ivan Penman. Mill Work, from new and approved
ss Castings of every description &c. &c.*

New York is iron.

Novelty Iron Works, Foot of 12th St. E. R. New York.
Stillman, Allen & Co., Iron Founders,
Steam Engine and General Machinery Manufacturers
John Penniman, American, 1817–1850
Lithographed by G. & W. Endicott, New York
Color lithograph with hand coloring, 18¹⁵/₁₆ × 31¹/₄ in., 1841–44
The Edward W. C. Arnold Collection of New York Prints, Maps, and Pictures,
Bequest of Edward W. C. Arnold, 1954 54.90.588

New York is grand,

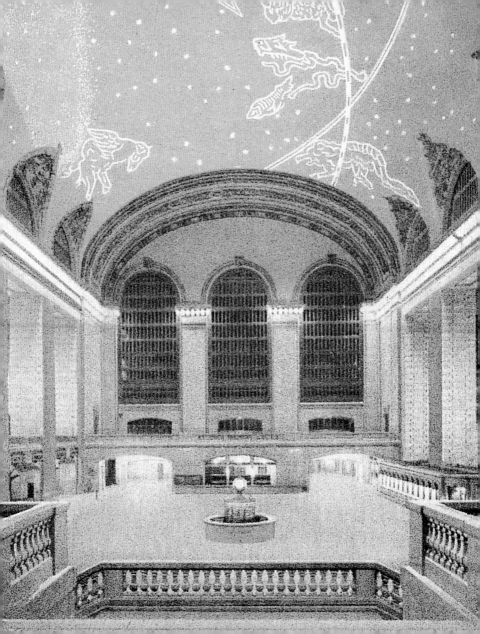

New York is conventional.

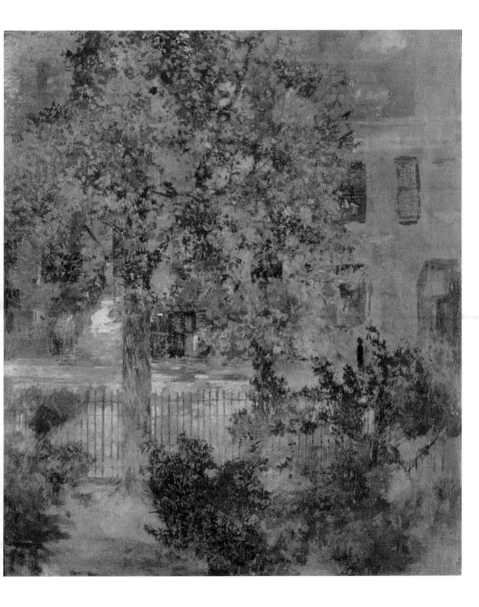

New York is religion,

6891. ST. PATRICK'S CATHEDRAL, NEW YORK. COPYRIGHT, 1903, BY DETROIT PHOTOGRAPHIC CO.

New York is commerce.

New York is cityscape,

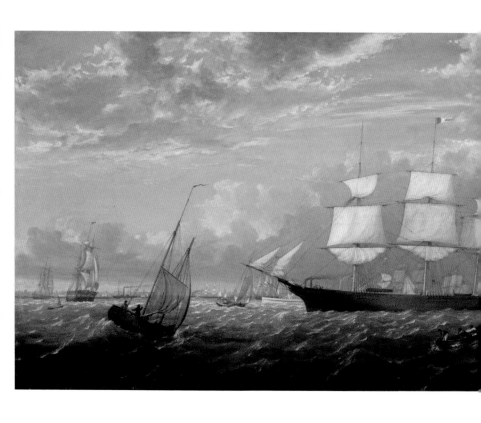

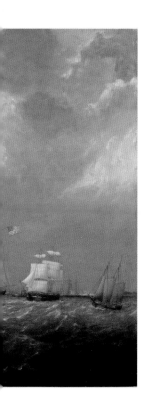

New York is seascape.

The "Golden State" Entering New York Harbor
Fitz Henry Lane, American, 1804–1865
Oil on canvas, 26 × 48 in., 1854
Purchase, Gift of Hanson K. Corning by exchange,
and Morris K. Jesup and Maria DeWitt Jesup Funds, 1974 1974.33

New York is tradition,

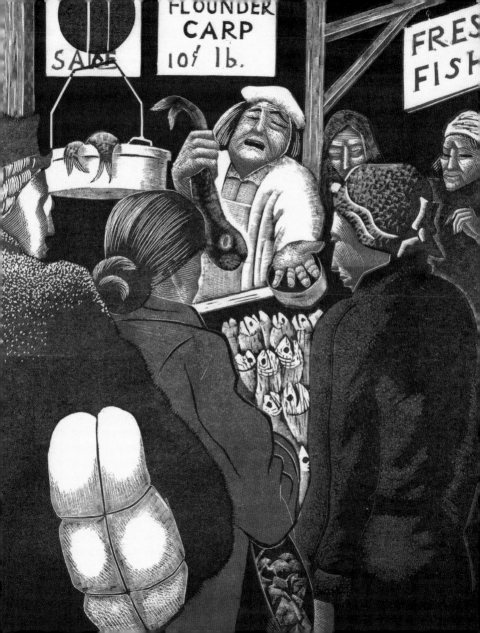

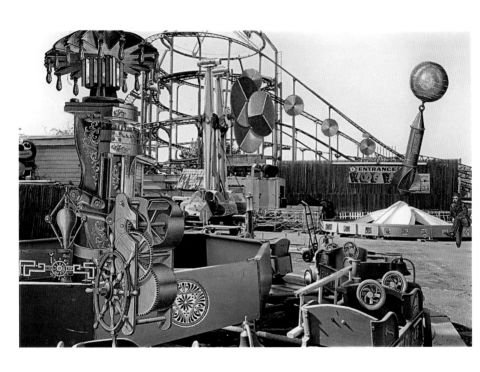

New York is invention.

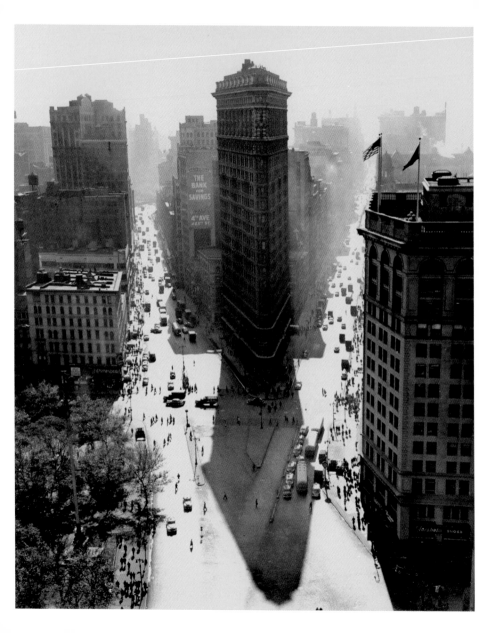

New York is authentic,

New York is atmospheric.

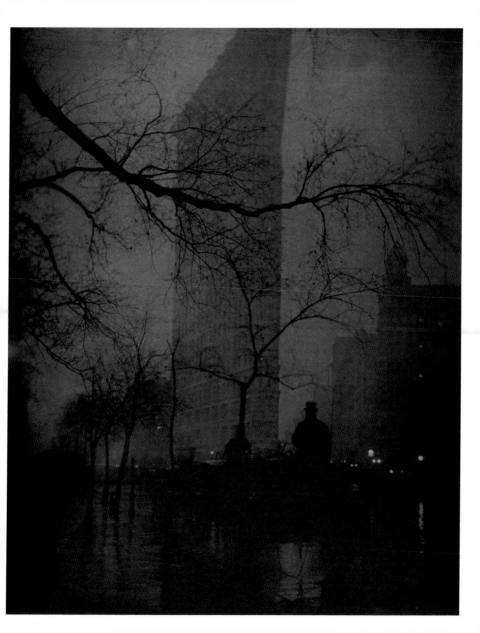

New York is sketched,

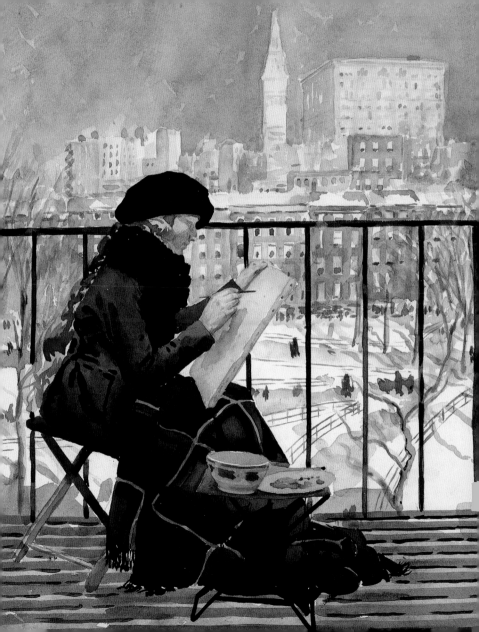

New York is photographed.

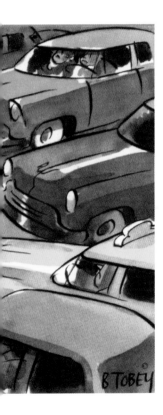

New York is fantasy,

Something's Got to Give
Barney Tobey, American, 1906–1989
Published by Fantasia (American Artists Group)
Commercial color process, 4 x 7 ¹/₂ in., 1957
The Jefferson R. Burdick Collection, Gift of Jefferson R. Burdick, Burdick 565, p. 40r(1)

New York is mythology.

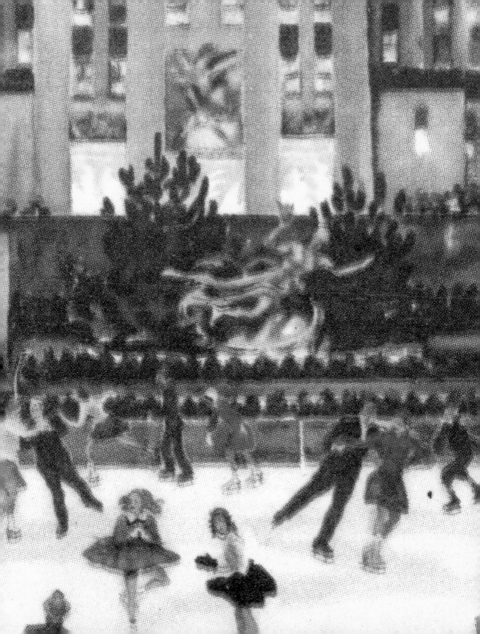

New York is outside a window,

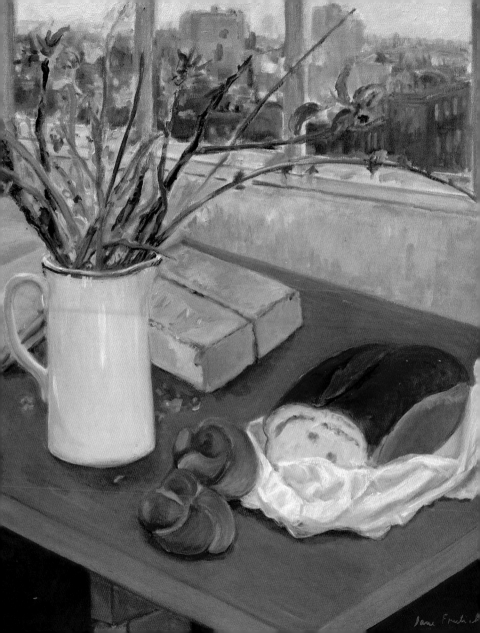

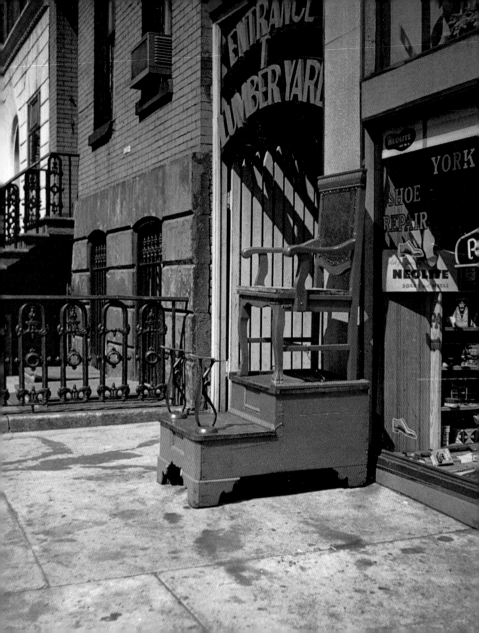

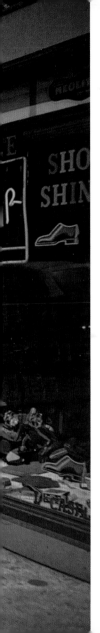

New York is on a street.

New York is vibrant,

New York is bleak.

[Red Corner Building with Checkerboard Sidewalk, New York City]
Jerry Shore, American, 1935–1994
Chromogenic print, 11 1/8 × 14 3/16 in., 1984–94
Purchase, Joyce F. Menschel Gift, 2007 2007.200
© Daniel Wolf Inc.

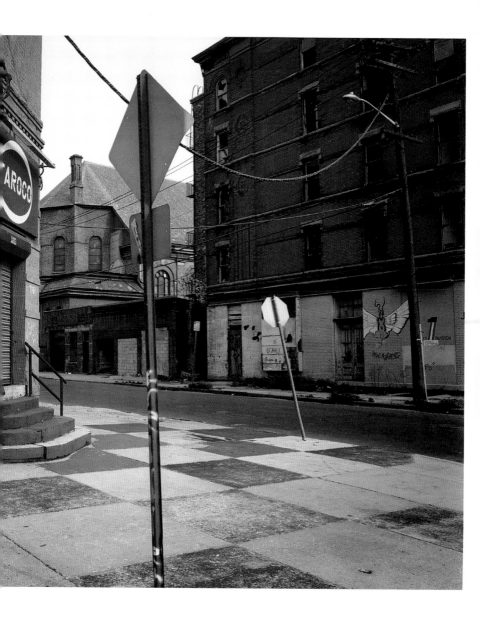

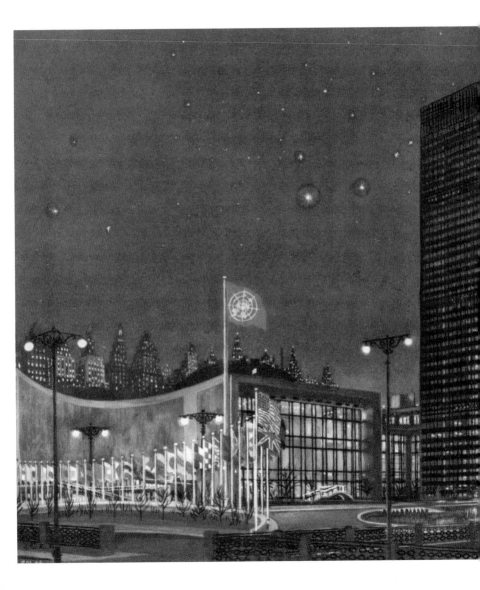

New York is politics,

United Nations with "Tree of Light and Hope"
Reinhold Naegele, German, 1884–1972
Published by Designers and Illustrators (American Artists Group)
Commercial color process, 5¹/₁₆ × 6³/₈ in., 1957
The Jefferson R. Burdick Collection, Gift of Jefferson R. Burdick, Burdick 562, p.IV(2)

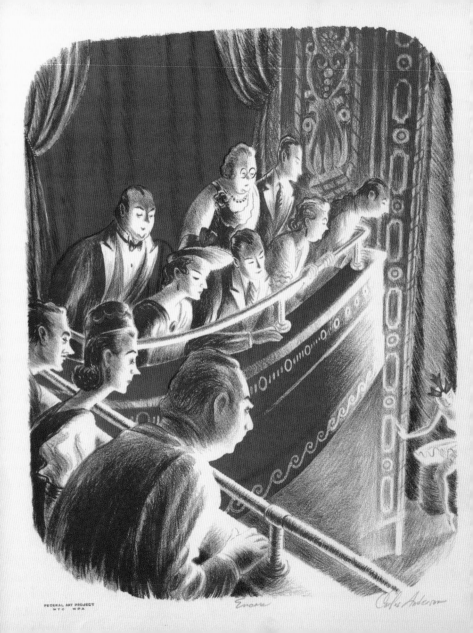

Encore

New York is theater.

Encore

Carlos Anderson, American, b. 1905

Published by the Works Progress Administration

Color lithograph, 12 x 9¹/₂ in., 1935–40

Purchase, Harris Brisbane Dick Fund, 1940 40.111.20

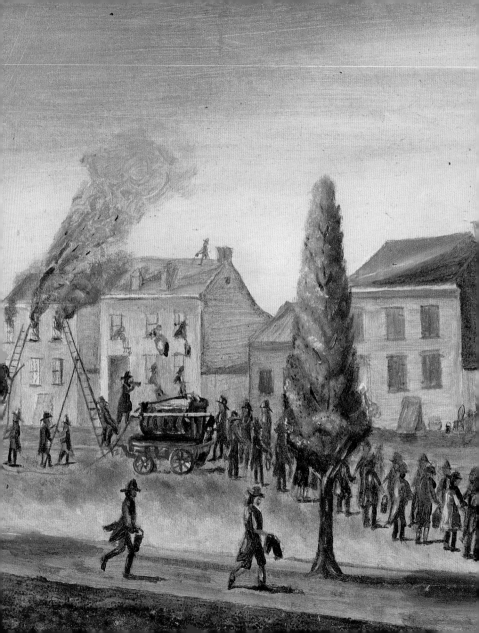

New York is before,

New York is after.

[New York Skyline]
Herman Landshoff, American (b. Germany), 1905–1986
Gelatin silver print, 15 1/4 × 15 1/4 in. 1940s–50s
Walker Evans Archive, 1994 1994.263.188

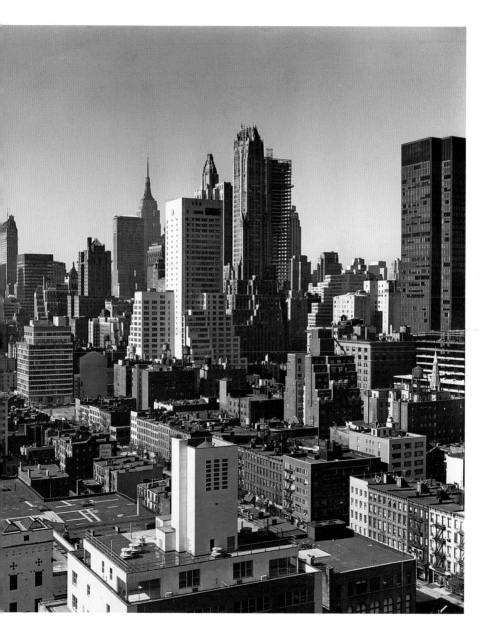

New York is literary,

Vignettes of Manhattan by Brander Matthews
Edward Penfield, American, 1866–1925
Published by Harper & Brothers Publishers
Commercial lithograph; yellow, vermillion, and blue, 12^{13}/$_{16}$ × 9^3/$_8$ in.
Gift of Bessie Potter Vonnoh, 1941 41.12.49

New York is gossip.

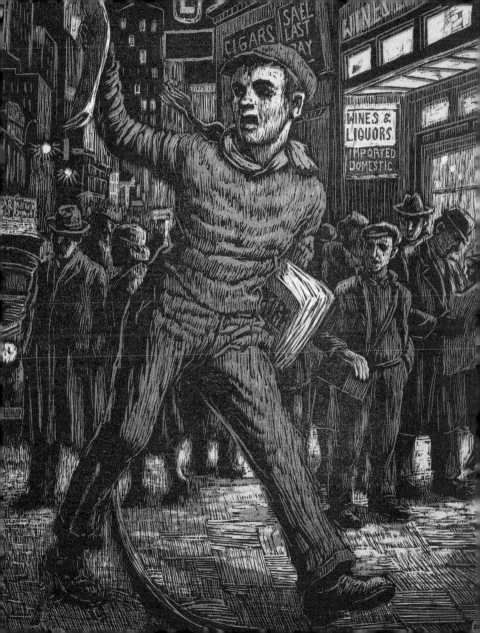

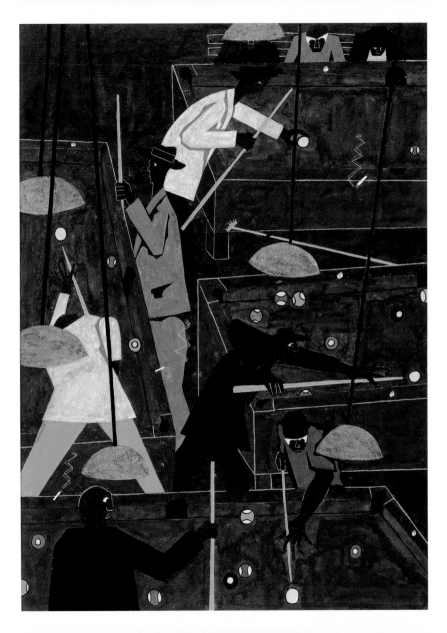

New York is a game,

New York is a party.

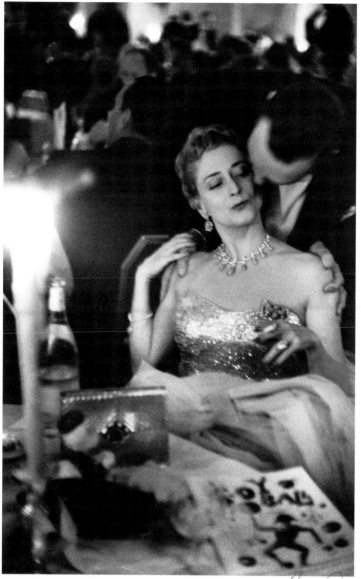

Robert Frank

New York is a stoop,

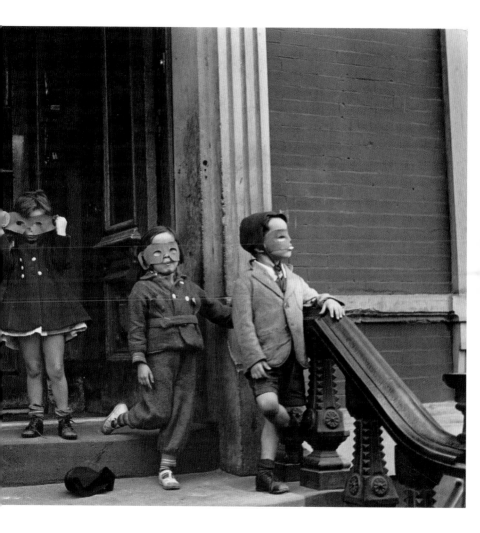

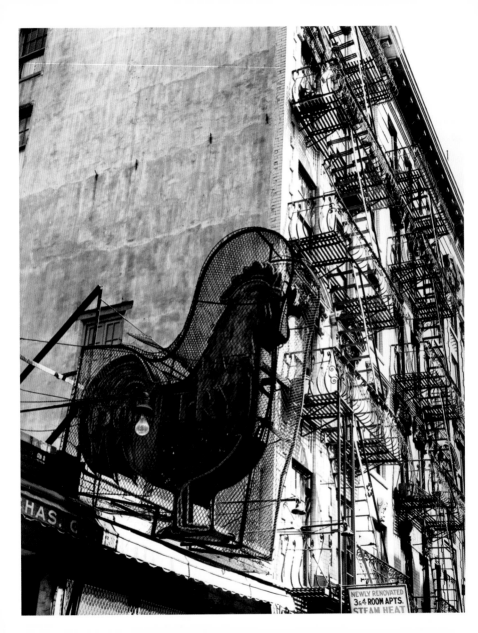

New York is a fire escape.

New York is abstract,

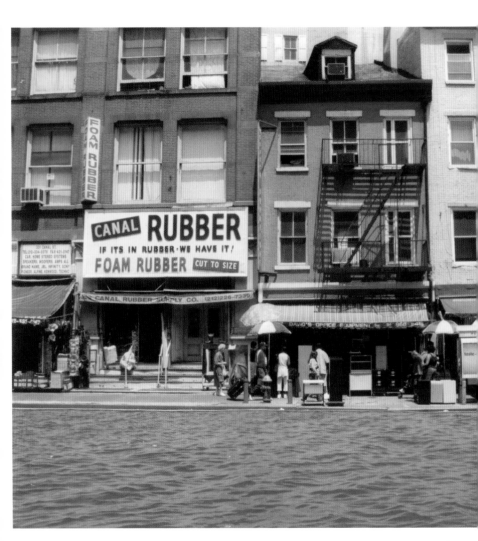

New York is pastiche.

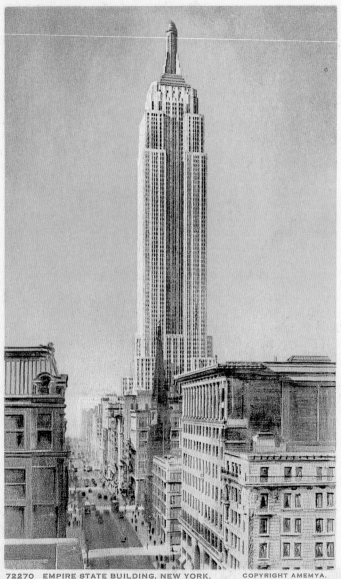

72270 EMPIRE STATE BUILDING, NEW YORK. COPYRIGHT AMEMYA.

New York is day,

New York is night.

Empire State Building, New York, N.Y.

Published by Detroit Publishing Company, American, 1931–32

Color lithograph, 5 1/2 × 3 1/2 in.

The Jefferson R. Burdick Collection, Gift of Jefferson R. Burdick, Burdick 417 p.11r(5)

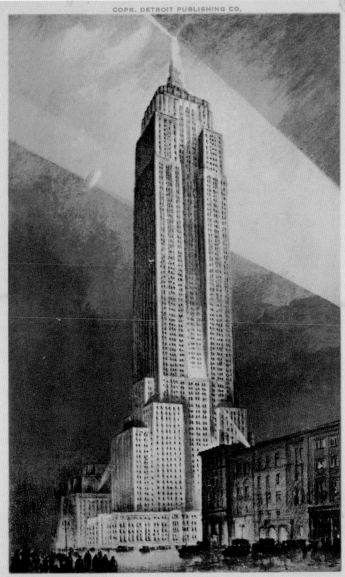

72260 EMPIRE STATE BUILDING, NEW YORK, N. Y.

New York is opulent,

New York is humble.

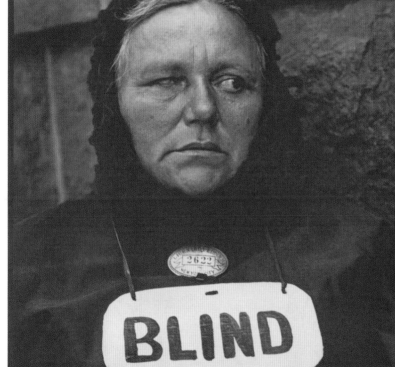

New York is columns,

14th Street Theatre
Perkins Harnly, American, 1901–1986
Gouache on paper, 17⅛ × 22 in., ca. 1940
Gift of New York City W. P. A., 1943 43.47.23

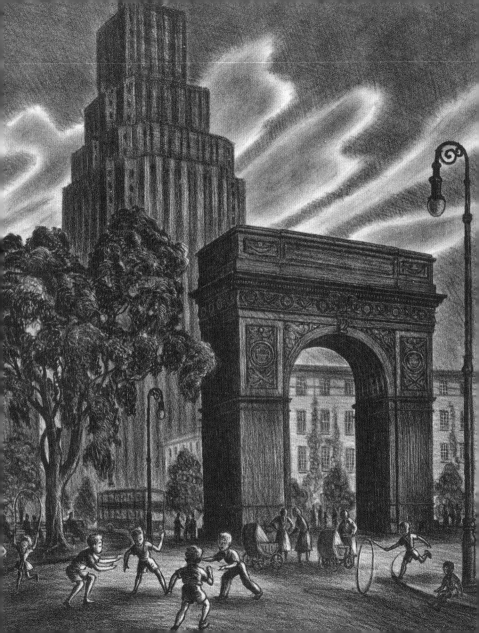

New York is arches.

Washington Square Evening (detail)

Carlos Anderson, American, b. 1905

Lithograph, 13 $^1/_2$ × 10 $^3/_4$ in., 1935–43

Gift of the Works Projects Administration, New York, 1943 43.33.642

New York is active,

Skating in Central Park (detail)`
Winslow Homer, American, 1836–1910
Lithographed by J. H. Bufford & Co., Boston
Color lithograph with hand coloring, $16^{11}/_{16} \times 27^{1}/_{16}$ in., 1861
The Edward W. C. Arnold Collection of New York Prints, Maps, and Pictures,
Bequest of Edward W. C. Arnold, 1954 54.90.605

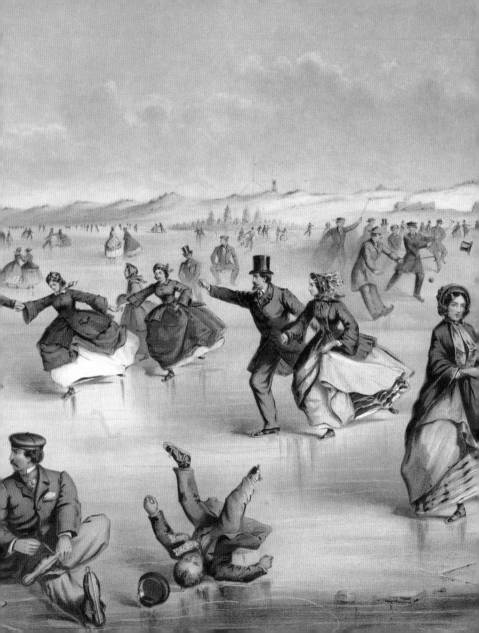

New York is idle.

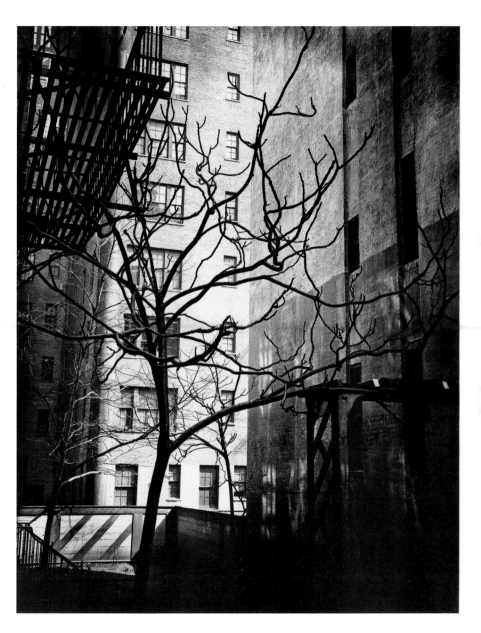

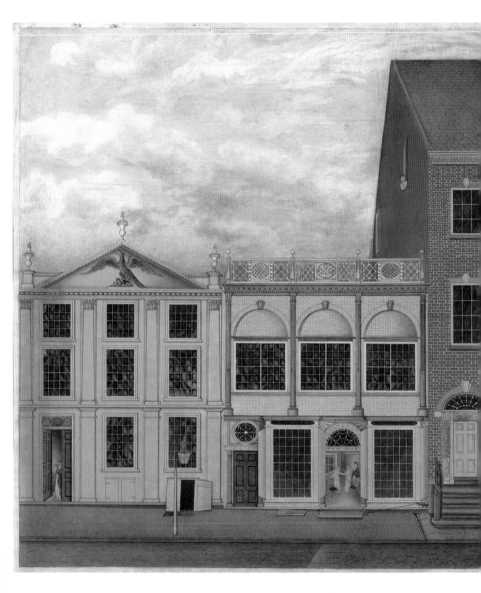

New York is trade,

New York is transportation.

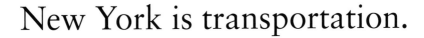

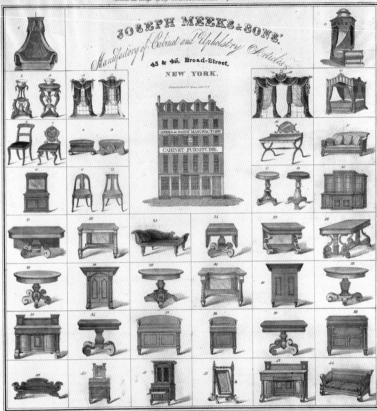

JOSEPH MEEKS & SONS'

Manufactory of Cabinet and Upholstery Articles

43 & 45, Broad-Street,

NEW YORK.

MEEKS & SONS MANUFACTORY

CABINET FURNITURE

New York is printed,

New York is etched.

Fifth Avenue, Noon (detail)
Childe Hassam, American, 1859–1935
Etching, 12$^1/_2$ × 9$^9/_{16}$ in., 1916
Gift of Mrs. Childe Hassam, 1940 40.30.25

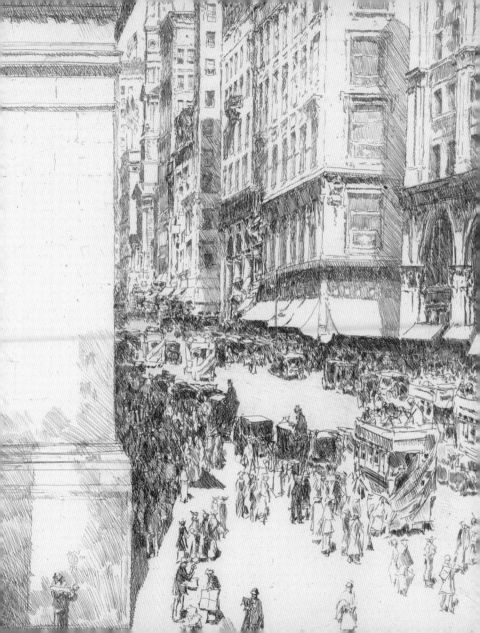

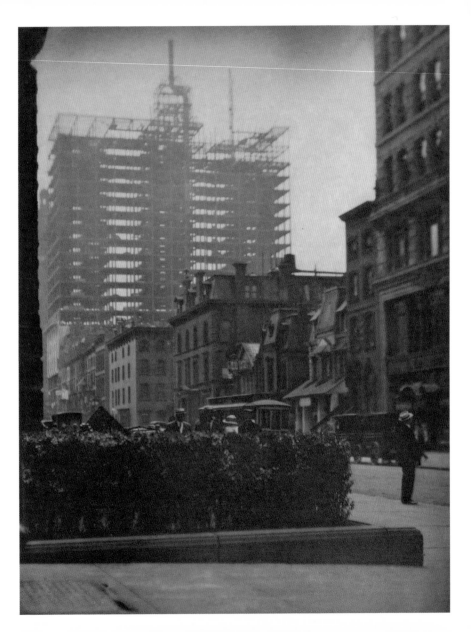

New York is constructed,

Old and New New York
Alfred Stieglitz, American, 1864–1946
Photogravure, 13$^1/_{16}$ × 10$^1/_{16}$ in., 1910, printed in or before 1913
Alfred Stieglitz Collection, 1949 49.55.17

New York is demolished.

Demolished Building, New York
Herbert Randall, American, b. 1936
Gelatin silver print, 13$^7/_{16}$ × 9$^1/_4$ in., 1963
David Hunter McAlpin Fund, 1966 66.642.1

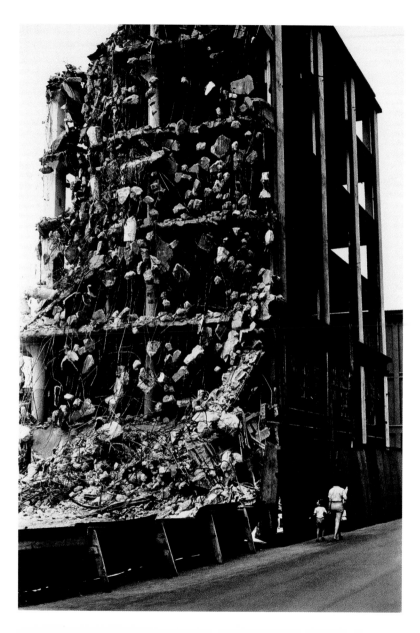

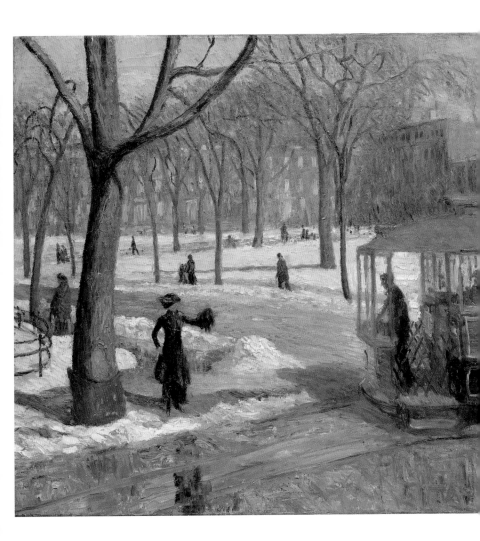

New York is movement,

The Green Car
William James Glackens, American, 1870–1938
Oil on canvas, 24 × 32 in., 1910
Arthur Hoppock Hearn Fund, 1937 37.73

New York is still.

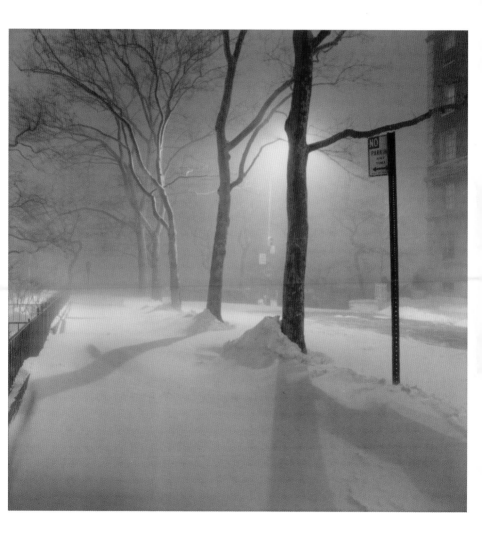

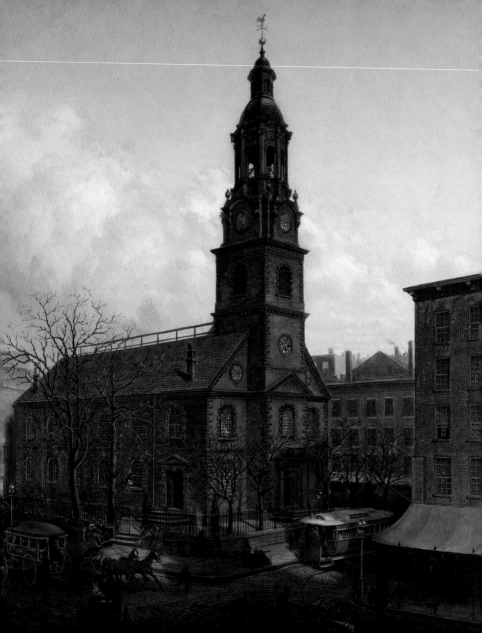

New York is the past,

New York is the future.

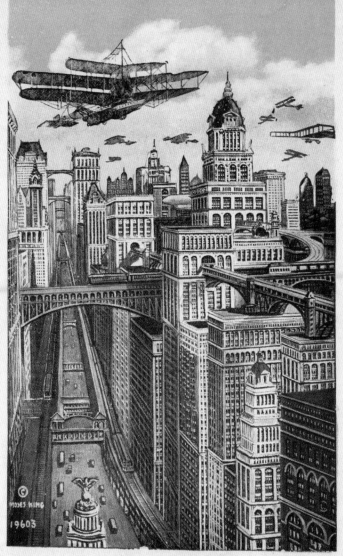

Produced by the Department of Printed Product, The Metropolitan Museum of Art: text by Mimi Tribble; interior design by Seoyeon Sally Lee; photography by The Metropolitan Museum of Art Photograph Studio.

Cover designed by John Gall.

Library of Congress Control Number: 2013945587

ISBN: 978-1-4197-1169-5

Printed and bound in Hong Kong

10 9 8 7 6 5 4 3 2 1

The Metropolitan Museum of Art
1000 Fifth Avenue
New York, NY 10028
www.metmuseum.org

115 West 18th Street
New York, NY 10011
www.abramsbooks.com